BRIDGET RILEY

Published on the occasion of the exhibition *Bridget Riley* at
Galerie Max Hetzler, Bleibtreustraße 15/16 and 45 and Goethestraße 2/3,
Berlin, 5 September to 24 October 2020

BRIDGET RILEY

PAINTINGS 1984–2020

Essay by Éric de Chassey
Biographical notes by Robert Kudielka

Galerie Max Hetzler Berlin
Holzwarth Publications

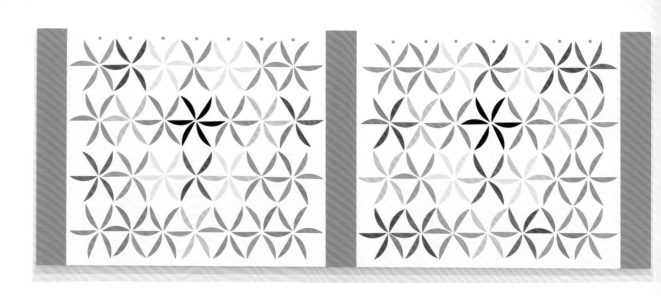

Installation view, Bleibtreustraße 15/16, Berlin 2020: *Joy of Living: Homage to Matisse*, 2012

Bridget Riley

When I made *Rêve* I realised that I'd found myself somewhere
I hadn't quite expected to be. I ran into David Sylvester and told
him that I would like to show him a painting. He came round,
looked at it and said, 'It's very like Matisse.' And then, after a
pause, 'It's not like Matisse at all' and after another pause, 'But
you might not have done it if you were not aware of Matisse.'
Then, finally, 'It shows there is more than one way out of Matisse.'
I told David that I had been thinking about Cézanne, that I had
been looking very carefully at Cézanne – and then found myself
at Matisse – and how surprising it was.

Since then I have come to believe that such is the train of
thought between artists, and even across generations, that
Matisse was always inside Cézanne, and so it was quite inevitable
that he would come out of him. Later I showed *Rêve* to Gary
Tinterow, who said, 'You may be surprised to find yourself at
Matisse, and you may venerate Cézanne more than Matisse but
I think you should now set about studying Matisse carefully.' That
was good advice and it has been a great joy to follow it, but my
curves have taken me my own way, I think. After *Rêve*, there were
paintings like *Two Greens and Blue* (2000), just three colours,
though there is a very elusive violet hanging over the full painting.

Bridget Riley in conversation with Michael Harrison, Kettle's Yard, Cambridge, 2011

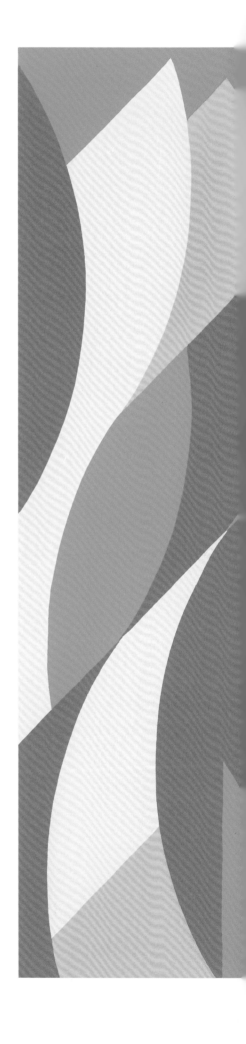

Rêve, 1999, oil on linen, 228 x 238 cm (89 $^{3}/_{4}$ x 93 $^{3}/_{4}$ inches)

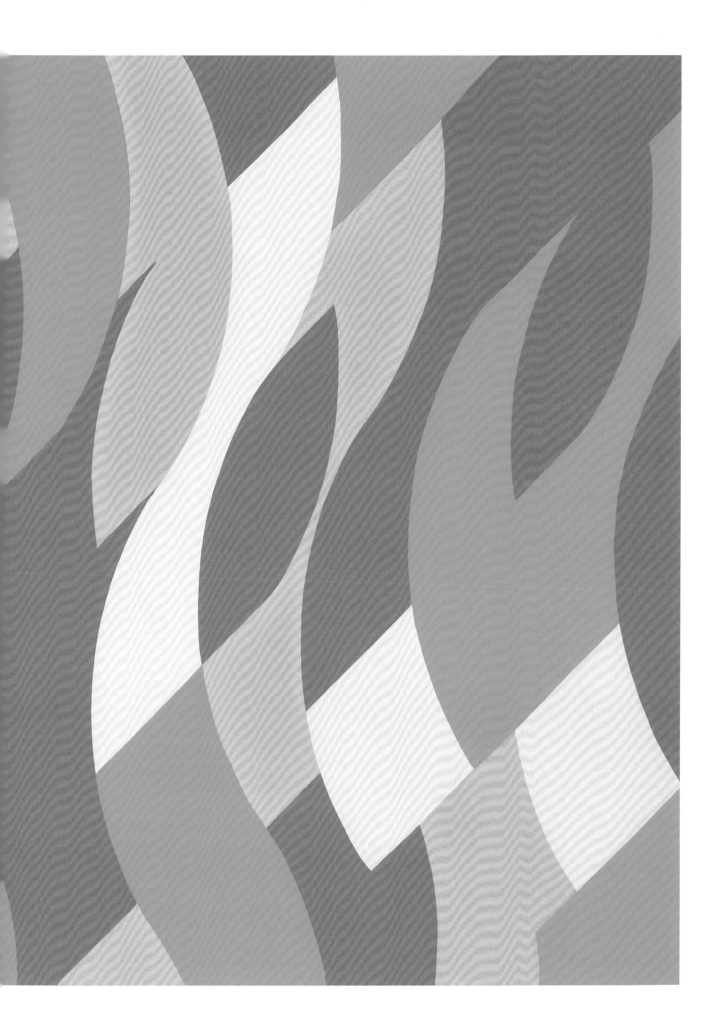

Installation views, Bleibtreustraße 15/16, Berlin 2020: *Joy of Living: Homage to Matisse*, 2012

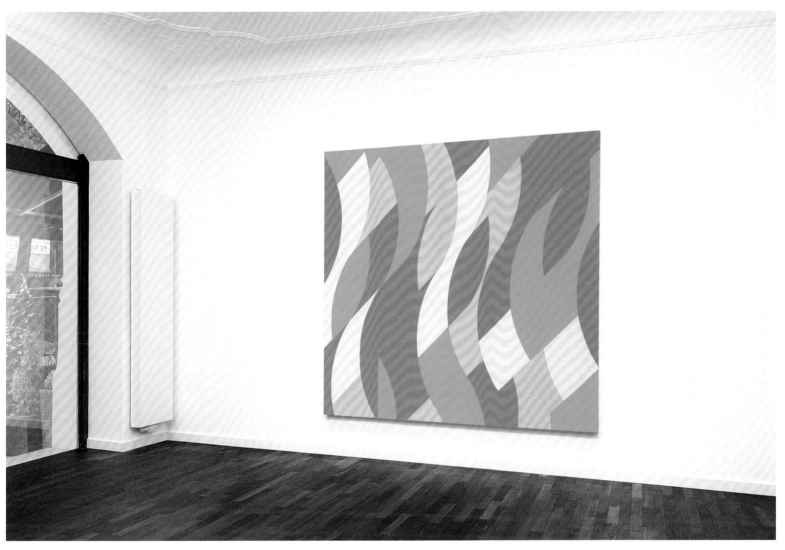

Rêve, 1999

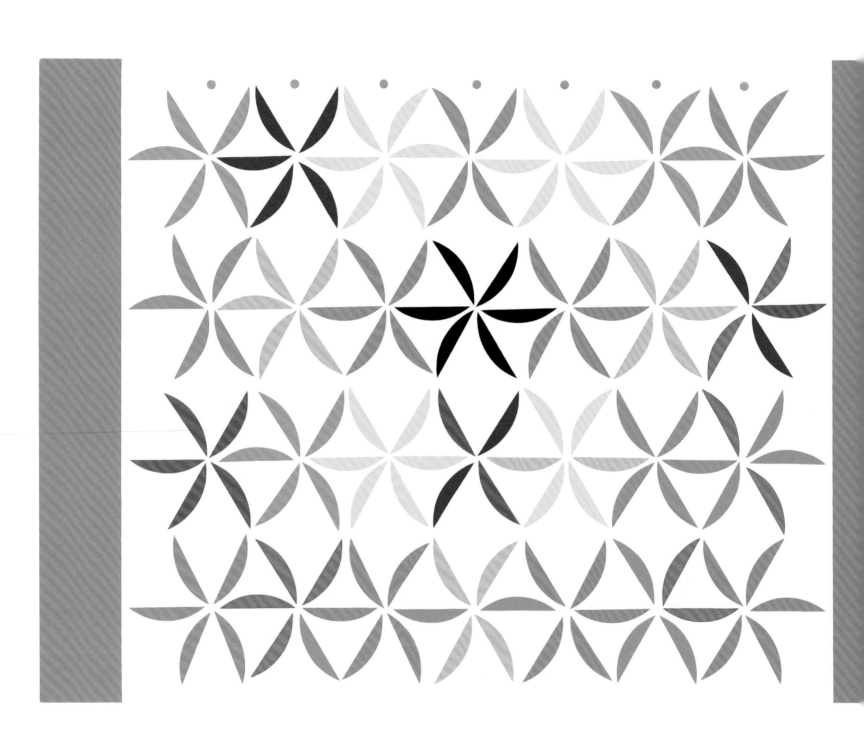

Joy of Living: Homage to Matisse, 2012, acrylic on linen, 158 x 421.5 cm (62 ¹⁄₄ x 166 inches)

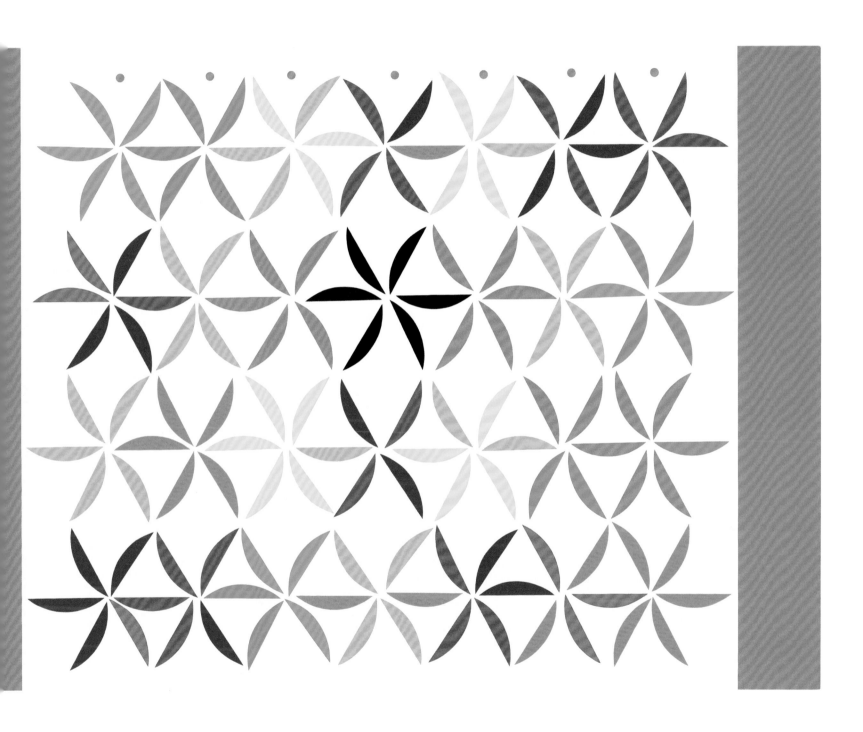

Blue Return, 1984, oil on linen, 177 x 153 cm (69 $^3/_4$ x 60 $^1/_4$ inches)

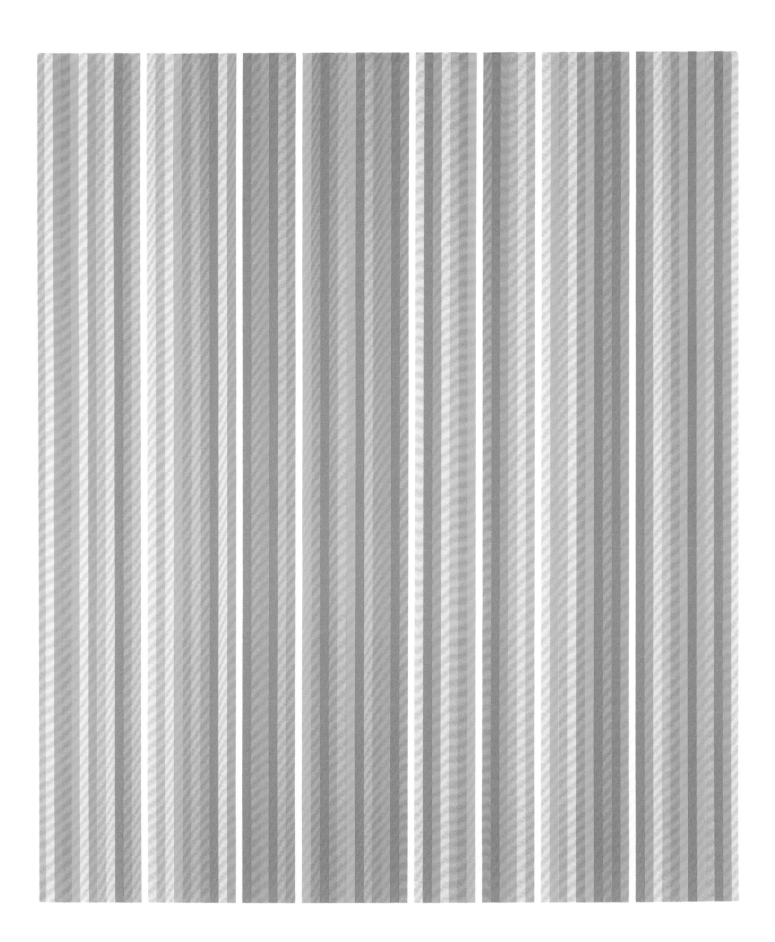

Arcadia 1 (Wall Painting 1), 2007, graphite and acrylic on wall, 239 x 441 cm (94 $^1/_8$ x 173 $^5/_8$ inches)

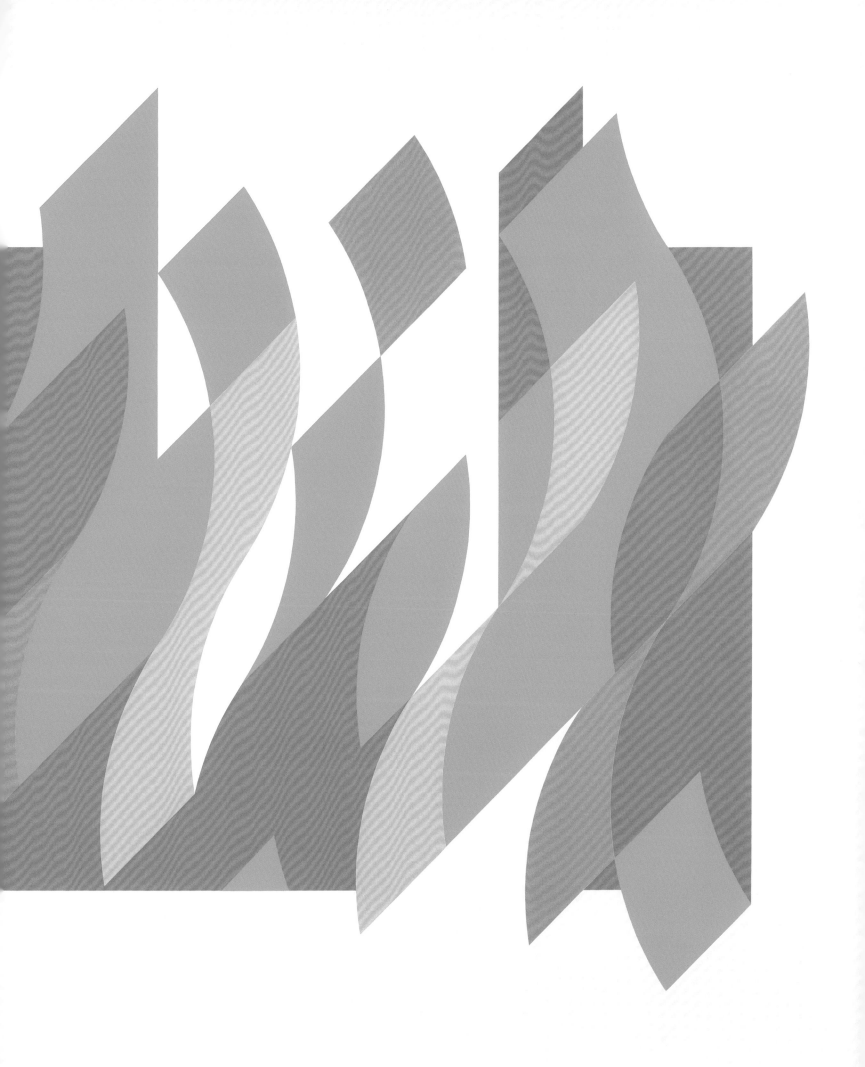

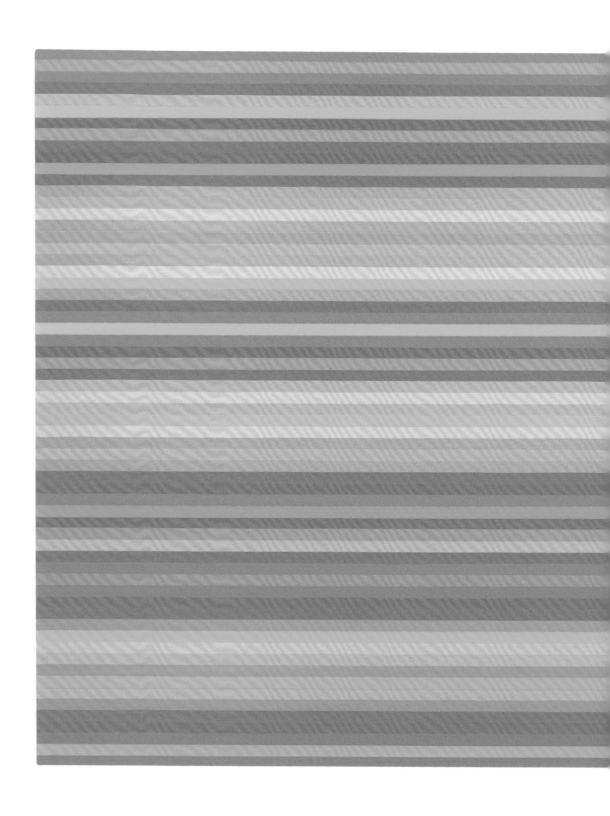

Blue Counterpoint, 2014, oil on linen, 160 x 305 cm (63 x 120 $^1/_8$ inches)

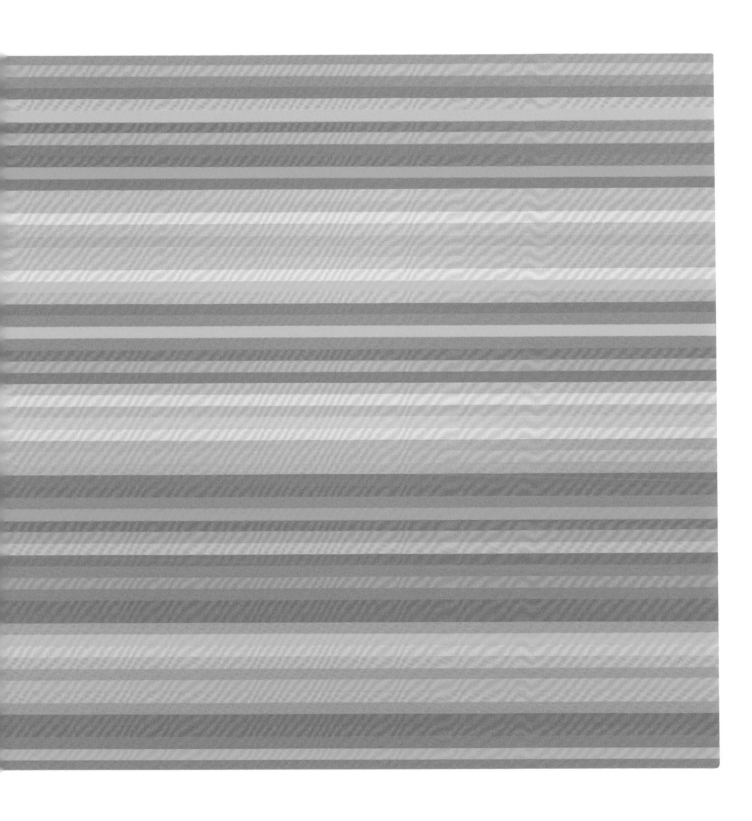

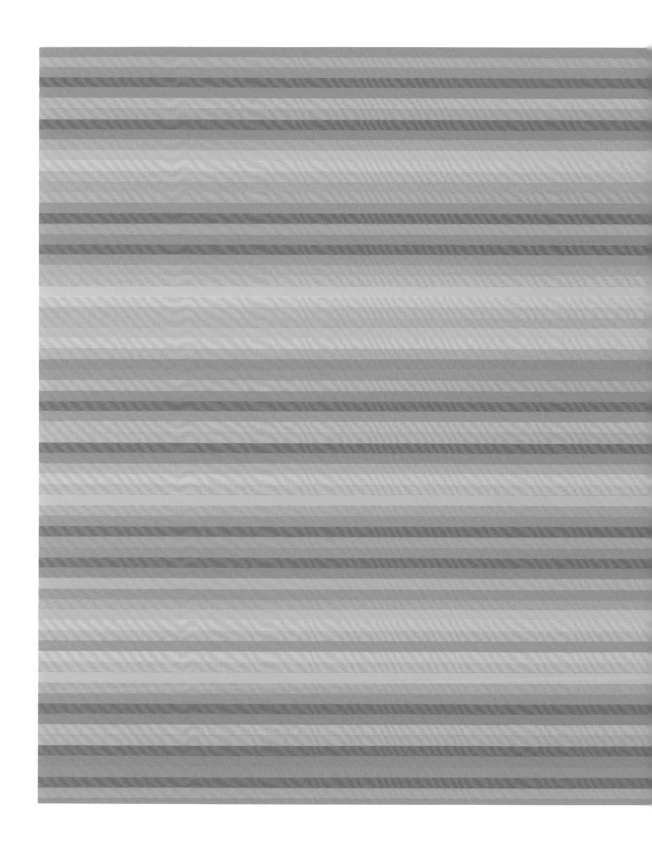

Red Overture, 2012, oil on linen, 186 x 353 cm (73 ¹/₄ x 139 inches)

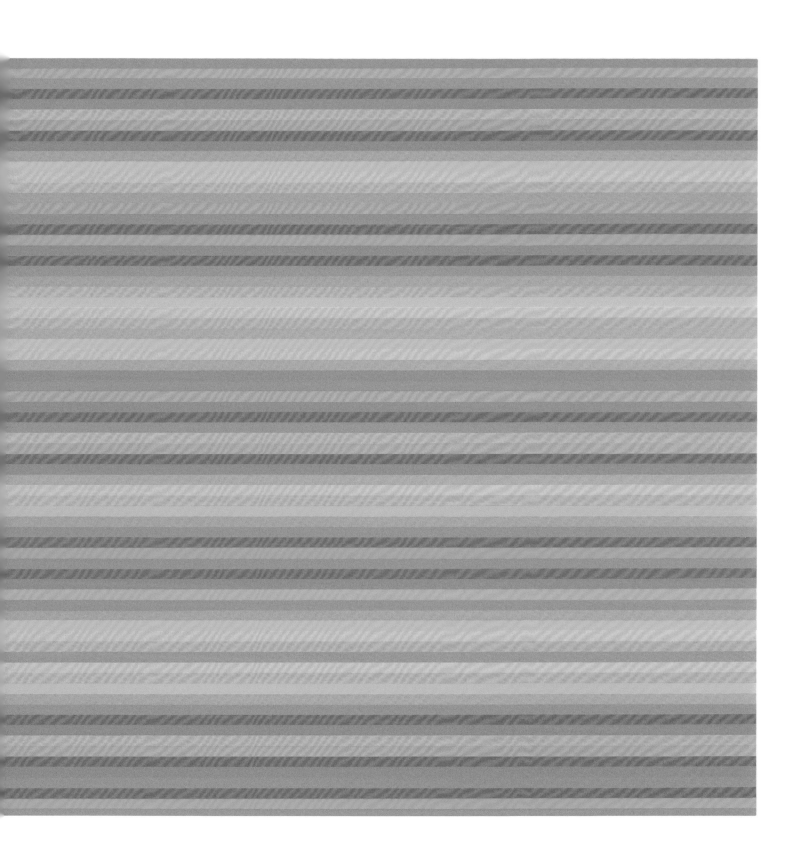

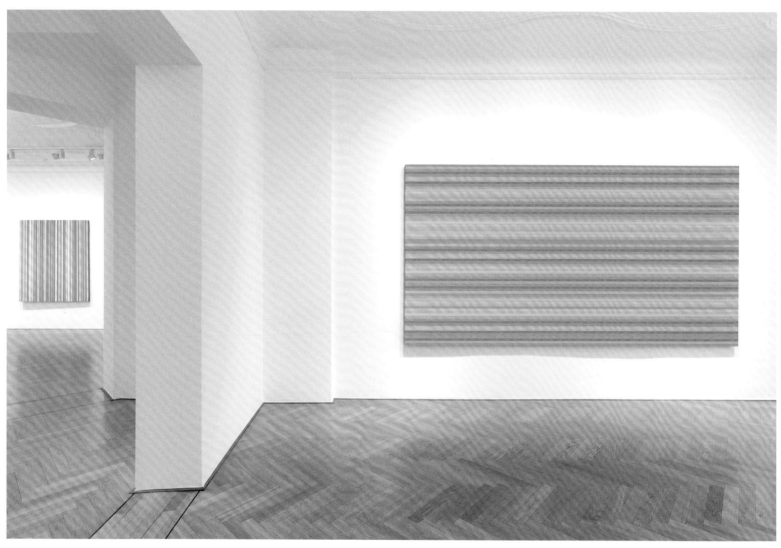

Installation views, Bleibtreustraße 45, Berlin 2020: *Blue Return*, 1984; *Red Overture*, 2012

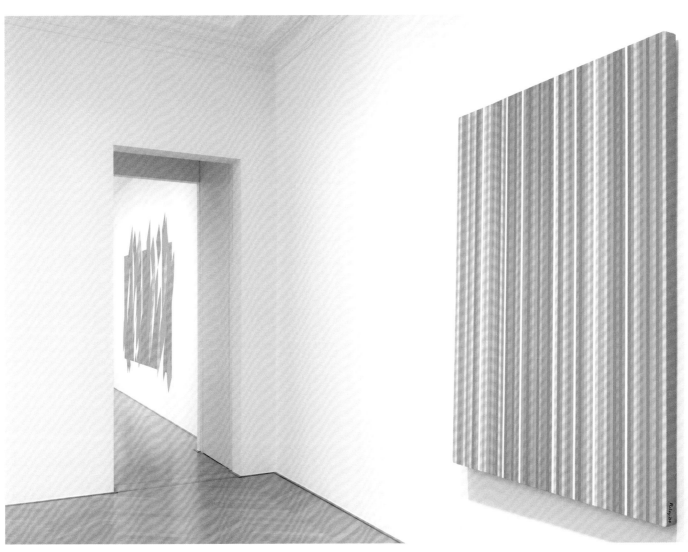

Arcadia 1 (Wall Painting 1), 2007; *Blue Return*, 1984

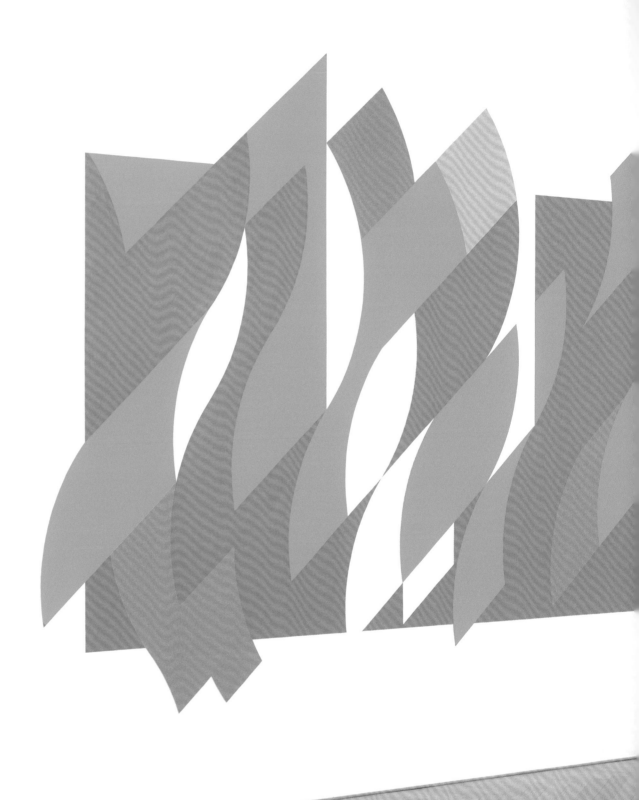

Installation view, Bleibtreustraße 45, Berlin 2020: *Arcadia 1 (Wall Painting 1)*, 2007

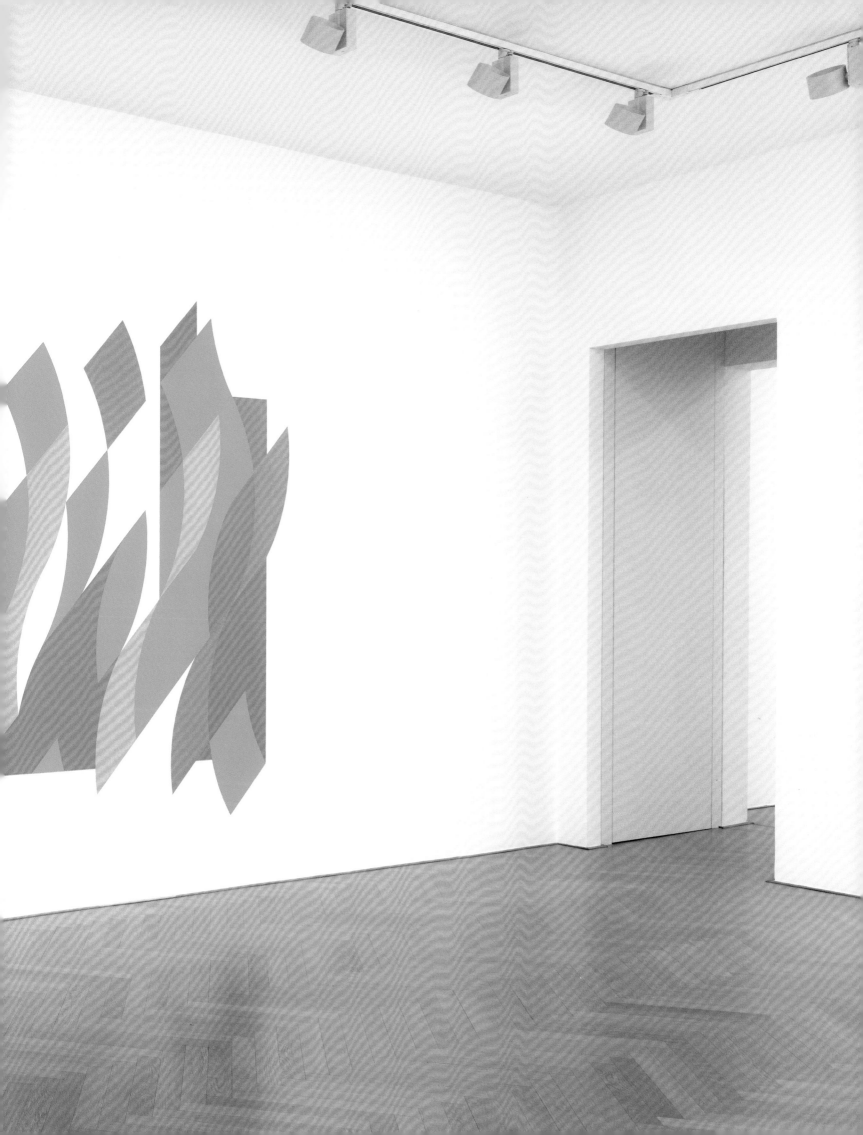

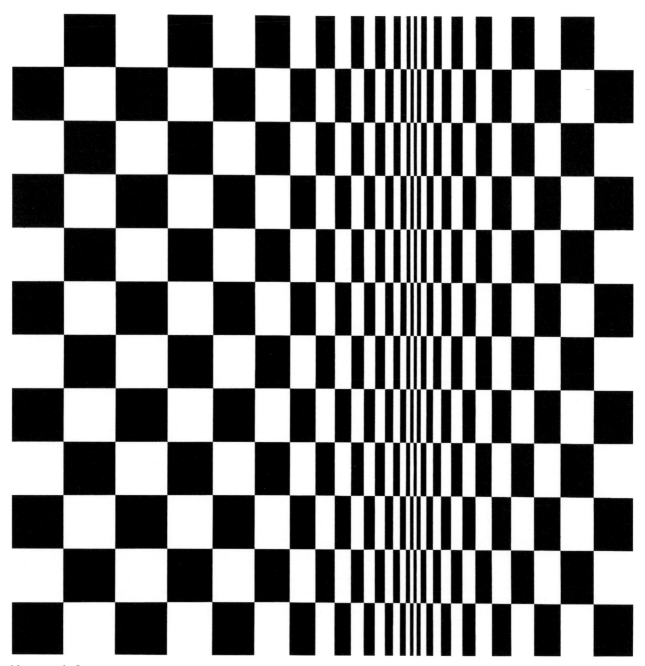

Movement in Squares, 1961, synthetic emulsion on board, 123.2 x 121.2 cm (48 $\frac{1}{2}$ x 47 $\frac{3}{4}$ inches). Private Collection, London

INTERVALLIC STRUCTURES

Éric de Chassey

In 1965, Bridget Riley succinctly described her method in words that have since become famous and often repeated when considering her work: 'The basis of my painting is this: that in each of them a particular situation is stated. Certain elements within that situation remain constant. Others precipitate the destruction of themselves by themselves. Recurrently, as a result of the cyclic movement of repose, disturbance and repose, the original situation is re-stated.'[1] The importance of this statement cannot be overemphasised. The fact that she has always remained faithful to the principles thus established enables us to understand one key aspect of Riley's aesthetics, which has set her oeuvre apart from those of all other abstract painters ever since the early 1960s: harmony encompasses contradictions; it is the result of labour and not an easy and immediate find; order is born out of destruction, not through an internal feud but rather through a paced resolution. The artists who took part in the international Op Art tendency, such as Victor Vasarely or Julio Le Parc, stop at the second step, destroying the stability of a situation to create a feeling of continuous movement and permanent agitation, ultimately leading to the abandonment of the picture plane and the translation of painting into an environment. The artists who established the basis of what came to be known as 'post-painterly' or 'minimal', such as Ellsworth Kelly, Kenneth Noland or Frank Stella, stop at the first stage, creating a pictorial situation that immediately establishes a stable harmony, so much so that, when they felt they had exhausted the possibilities contained in such a method (with the notable exception of Kelly), they created works that start with overtly clashing elements and reach a conclusive state by pitting those one against the other. As for the artists who have turned to abstract painting since the late 1970s, when they don't re-enact previous artistic situations according to postmodern strategies, they either believe in immediate harmony, emphasise destruction as a creative tool or depend on the unleashing of contradictory elements.

In Riley's most recent paintings, the *Intervals* series, she applies the three-stage principles she established in the creation of *Movement in Squares* in 1961 (p. 24). The particular situation stated here of four to six horizontal bands of four to five colours forms a rectangular unit on a white (or, rather, an off-white) surface. This unit is repeated vertically several times, admittedly with changes in the order of colours, so that its regularity, perceived at first glance as a kind of primary order, is thrown into question and destroyed. The mind and the eye become agitated and attempt to follow the differences between each of the four or five units in a process of comparison. When it has become clear that there is no stable intellectual principle behind the permutations – but only a visual search – the mind and eye can engage in and accept the harmony of the whole picture, established as it has been by the rhythm of changes in its units.

As has generally been the case in Riley's recent paintings, the *Intervals* take stock of the means and ways that the artist has used previously. Their colour scheme can be

compared to that of the *Measure for Measure* series, begun in 2016 and still developing. In the first works from that series (e.g. *Measure for Measure 13*, 2017; p. 49), Riley used only three colours. She had used the three greyed secondary colours – described as off-green, off-violet and off-orange – already in *Vapour*, a key painting from 1970 (p. 27) (of which she made a new version in 2009), realising that the tonal closeness of this chromatic triad enables its components to become unified when you look at the painting as a whole, while retaining their discrete identities when you look closely, creating an overall feeling analogous to the natural event that the title *Vapour* refers to ('the fugitive quality of something which is obscure or difficult to penetrate... it de-materialises the material'[2]). In the *Measure for Measure* series, Riley reached her resolution through carefully selecting the number of discs of each colour, so that, in the final compositions, none of them dominates, even if in general there are actually more violet discs than green and orange ones. At the same time that she was bringing the first *Intervals* paintings into existence (the studies for which seem to date from the summer of 2017, the first with three colours, then with four – they didn't give birth to realised paintings until much later), she added a fourth colour, an off-blue turquoise hue, to the *Measure for Measure* paintings – e.g. *Measure for Measure 36* (2019; p. 31) or *Measure for Measure 42* and *43* (2020; pp. 50/51 and 52/53) – in a development which greatly enriched the situation previously stated. The same four colours are found in *Intervals 1* (p. 57) and *2* (both 2019), to which the artist added, starting with *Intervals 3* (2019), the turquoise, now composing each unit of five differently coloured stripes. Then, in 2020, she took a direction that initially seemed to contradict the underlying principle of the first *Intervals* (i.e. that of not repeating a colour in each unit) by repeating one of the colours in each unit (e.g. *Intervals 7* and *8*, both 2020; pp. 59 and 61). This decision could not be made before the first principle had been explored; it grew out of, so to speak, the limitations the artist had given herself, according to a process she described in 1970: 'My direction is continually conditioned by my responses to the particular work in progress at any given moment. I am articulating the potentialities latent in the premise I have selected to work from.'[3]

Another feature that the *Intervals* share with the *Measure for Measure* paintings is the fact that the composition is on a white (or off-white) ground: this ground acts as a neutral border (an interval) around the units (which are themselves intervals of another kind, akin to melodic intervals in music, i.e. the differences in pitch between the compositional elements), which turns it into an active element in the picture plane when seen between them. In the *Measure for Measure* series, the white surface between the greyed-coloured discs is filled by white after-images, brought about by the scanning movement of the searching eye, which so composes a homogeneous field made of circles both present physically and *in absentia*. In the *Intervals*, the off-white spaces between the units form a repetition of more or less identical apertures, or rather unmeasurable depths which are impossible to grasp because they are continuous with the borders: they are not active as such, but as a way of bringing together the coloured units and establishing a simultaneous contradiction that works hand in hand with the identical width of the coloured bands, soothing the agitation brought about by the movement of colours from one unit to another. Riley herself compares this feature with what happens between the double lines in Piet Mondrian's paintings of the 1930s[4], and it should be remembered that the Dutch painter

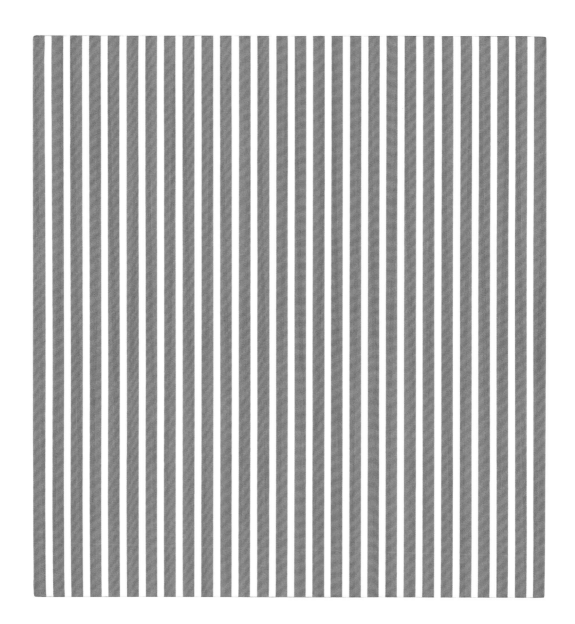

Vapour, 1970, acrylic on linen, 96 x 90 cm / (37 $^3/_4$ x 35 $^3/_8$ inches). Private Collection, London

saw the introduction of this device in his neo-plastic system as 'heading toward the plane'.[5] Wanting to avoid too strong a disruption and contrast (which did not appear in the *Measure for Measure* series), Riley lowered the white in the *Intervals* to a colour which is slightly greyed – as the five hues themselves are.

The use of a border or surround can be found or seen in Riley's previous work. It first appeared in 2014–2015 with the return of black and white compositions using a triangular unit on canvas (e.g. *Cascando* and *Rustle 2*, 2015; pp. 42/43 and 41) that accompanied Riley's three *Quiver* wall paintings (see *Quiver 3*, 2014; pp. 35–37). In 2014 she worked on a long horizontal canvas using the black and white triangles, brought into focus through a re-engagement with *Tremor*, a 1960s painting, which she saw unexpectedly in an exhibition at the Gemeentemuseum in The Hague. 'One's perception changes. I see differently through the changes I make whilst working.' The black and white image on this new long horizontal canvas ran edge to edge in the same way that the vertical stripe paintings had done before. But with this new use of the black and white triangles, it was in danger of being seen as continuous. Riley remedied this by introducing in her next painting a narrow border establishing a decisive edge for the composition, re-affirming its autonomy and opening our perception to further enquiry. In the *Intervals*, as it did there, the border

throws into relief the units that it delimits, while making sure that the composition becomes a whole without defeating the discreteness of its elements (or that the discreteness of the units is not destroying the possibility of the picture to finally be perceived as a whole), albeit, contrary to what happened in these works from 2015, without suggesting the creation of a vista. It also has, according to Riley, the effect of 'slowing down' the image, 'the speed at which you perceive something'.

Intervallic structuring first surfaced in Riley's paintings in 1967, although at that time the basic units selected were neither single one-colour shapes nor pictorial elements harmonising with the field. The first coloured stripe paintings were composed of several bands of colour that travelled vertically, horizontally or diagonally from one side of the composition to the other, ringing changes in colour relationship and proportion along their respective axes, and alternating with regular white stripes, which can be seen as either a ground or as intervals: in *Rise 2* (1970; p. 29) they operate within in a triad of turquoise, cerise and ochre, whose juxtapositions change along their axis, the cerise stripe being narrower than the two others. In the 1980s, when Riley returned to working with the stripe, her interest shifted to pictorial space and depth (e.g. *Blue Return*, 1984; p. 13) and since 2009 she unified her visual field in a search for plasticity (e.g. *Red Overture*, 2012; pp. 18/19).

For the *Intervals* paintings, each unit of several bands is isolated as a rectangle, separated by the off-white ground. 'If I had taken it to the edges of the canvas, it would have been just another stripe.' In a way this decision had been anticipated twice, first in gouaches on paper that served as studies for the first series of stripe paintings (or in compositions made of two-colour concentric circles, executed in 1970, such as *Closed Discs: Turquoise, Cerise, Ochre*, which did not go beyond the study stage before 2010, when the artist made an isolated work, titled *Closed Discs*, based on the studies), and for a second time in the 2012 painting *Joy of Living: Homage to Matisse* (pp. 10/11), which was not shown before 2020 (nor was it included in *Bridget Riley: The Complete Paintings*, published in 2018), when the realisation of the *Intervals* paintings enabled a better understanding of its methods, despite its Matissean character. In *Joy of Living*, there are at least three units: the vertical bands (which do not change in their three occurrences), the small dots at the top (which vary from green to two different blues) and the coloured segments whose juxtaposition creates the perception of active dancing units, some many-coloured, some black on white.

In the *Intervals*, the means are much reduced: each rectangular unit is divided into – or built up of – the same number of adjacent bands, repeating the same colours, albeit in a different order each time. This is the stated situation, recognisable in a glance, based on simple but strict rules. The rule of non-repetition of a colour in each rectangle, which prevailed at the beginning of the series in the pictures painted with four or five bands per unit, has already suffered at least one exception, not immediately noticeable, proving that each situation can be immediately contradicted: when Riley increased the number of stripes in each rectangle, as she did in *Intervals 7* and *8*, going from five to six, she did not increase the number of colours accordingly. In these pictures, one colour is repeated in each unit (counter-intuitively, that is to say, following her own logic, she did not set a new rule of non-repetition, and some colours are repeated in two or three

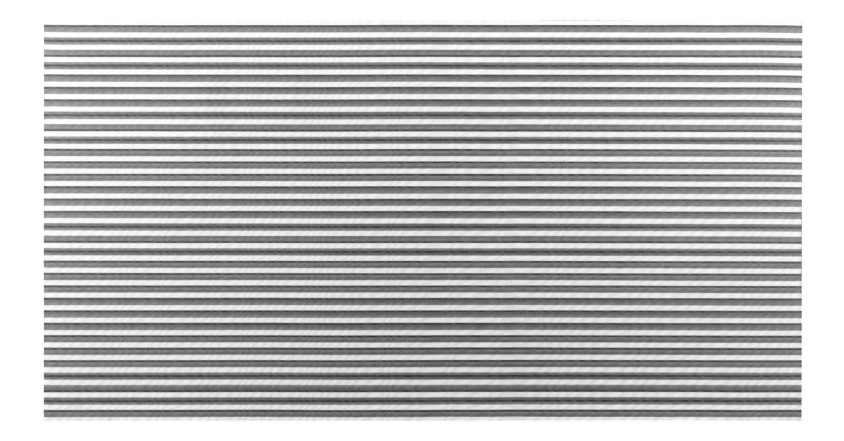

rectangles, while others remain a single instance throughout). If Riley had repeated the same combination of coloured stripes, she would have created a rather static composition based on the multiplication of units that would have sat completely still on a surface animated only by the diverse units. Instead, she immediately destroys her foundational equilibrium, reinforced by the close tonal range of her colours (almost, but not quite, identical, contrary to the *Measure for Measure* series), by varying what happens in each unit: the painting 'may appear static at first glance, but the viewer's engagement will bring it to life'.[6] And at the same time, in most pictures of the series, she suggests the possibility of continuity between the units by redoubling the same colour around the white interruptions, twice in *Intervals 1* (2019; p. 57), and *Intervals 8* (2020; p. 61), three times in *Intervals 7* (2020; p. 59), and *Intervals 9* (2019; p. 63).

The effect is of a vertical cascading of permutations, a series of slow ripples, interrupted and relaunched rhythmically by a white zone. Contrary to what happened in most horizontal stripe paintings from the 1960s (Riley noted in 1985 that, in *Rise 2*, 'the entire sequence… rise[s] from the bottom of the canvas to the top in a scarcely perceptible manner as through water affected by depths, currents and filtering light'[7]), this cascading does not proceed in one direction only but gently suggests sub-movements of various densities and orientations, especially as, even within a close tonal range, each colour keeps its own spatial potential. (On an early study on paper for the *Intervals*, with only three colours, the artist noted: 'Greyed Green Convex', 'Greyed Purple Plain', 'Greyed Orange Concave'.) If I may take the liberty of picking up Riley's metaphor, I will compare the effect of the *Intervals* to what you see horizontally when looking at waves hitting the shoreline on a quiet day, each one advancing and receding without being completely isolated from the next, each one different and yet similar, each one participating in the ever-changing unity

Rise 2, 1970, acrylic on canvas, 165.7 x 322.1 cm (65 ¼ x 126 ¾ inches). Dallas Museum of Art, Foundation for the Arts Collection, gift of Mr. and Mrs. James H. Clark

of water. You know that there are discrete elements and you can even name them, but their repetition and internal variations create in your eye and in your mind what the artist describes as 'a rhythm within each block', that slowly builds up a new global unity, a global rhythm made of several sub-rhythms.

In the *Intervals*, as in the *Measure for Measure* paintings, the conflicts and contradictions are subtle – or non-assertive – but they clearly are fundamental to the kind of harmony that Riley strives for and achieves in each picture. She has made it more and more monumental, expanding the sizes of her canvases without altering the scale of the units (while *Intervals 1* is 198.5 x 145.5 cm, *Intervals 8* is 265 x 189 cm[8]), addressing the body of the viewer with a pictorial body which remains graspable in a single glance but embraces more space as its size grows. This kind of harmony – a slow reconciliation, so to speak, going 'from a state of certainty to uncertainty and then to resolution'[9] – might be exactly what we need in these times of division and strife (political, social and psychological), where oppositions are anything but too clearly stated and the very possibility of unity denied.

[1] Bridget Riley, 'Perception Is the Medium' (1965), in Robert Kudielka (ed.), *The Eye's Mind: Bridget Riley, Collected Writings 1965–2009* (London: Thames & Hudson, 2009), p. 90.

[2] Bridget Riley (2014), quoted in Richard Shiff, 'The Unaccountable', in *Bridget Riley: The Stripe Paintings 1961–2014*, exh. cat. (London: David Zwirner, 2014), p. 34.

[3] Bridget Riley, quoted in Maurice de Sausmarez, *Bridget Riley* (London: Studio Vista, 1970), p. 91.

[4] Bridget Riley, in conversation with the author, 22 September 2020. Unless otherwise noted, quotes are from this conversation.

[5] Piet Mondrian, letter to Jean Gorin, datable from 31 January 1934, in Yve-Alain Bois (ed.), 'Mondrian, Vantongerloo, Torres-Garcia, Hélio, Bill, etc.: Lettres à Jean Gorin', *Macula 2* (1977), p. 130.

[6] Bridget Riley, speaking about *Cosmos* (2016–2017), in conversation with Paul Moorhouse, 'In the Studio', in *Bridget Riley: Cosmos*, exh. cat. (Christchurch: Christchurch Art Gallery Te Puna o Wauwhetu; London: The Bridget Riley Art Foundation, 2017), p. 21.

[7] Bridget Riley, 'Analysis of *Rise*' (1985), hand-written, sheet 7, private collection.

[8] The same progression towards monumentality takes place in the *Measure for Measure* series. Whereas the first ones were all the same dimensions (93.6 x 93.6 cm for the 2016 paintings), they became larger, reaching 156.8 x 156 cm in *Measure for Measure 13* (2017), and giving way to rectangular paintings that stem more explicitly from the wall paintings in the same series and lead the viewer to move laterally in front of them (*Measure for Measure 43* from 2020 is 102 x 304.5 cm).

[9] Paul Moorhouse, 'Bridget Riley: The Stripe Paintings 1961–2012', in *Bridget Riley: Die Streifenbilder / The Stripe Paintings 1961–2012*, exh. cat. (Berlin: Galerie Max Hetzler and Holzwarth Publications; London: Ridinghouse, 2013), p. 42.

Measure for Measure 36, 2018, acrylic on canvas, 125 x 125 cm (49 ¼ x 49 ¼ inches). Private Collection, London

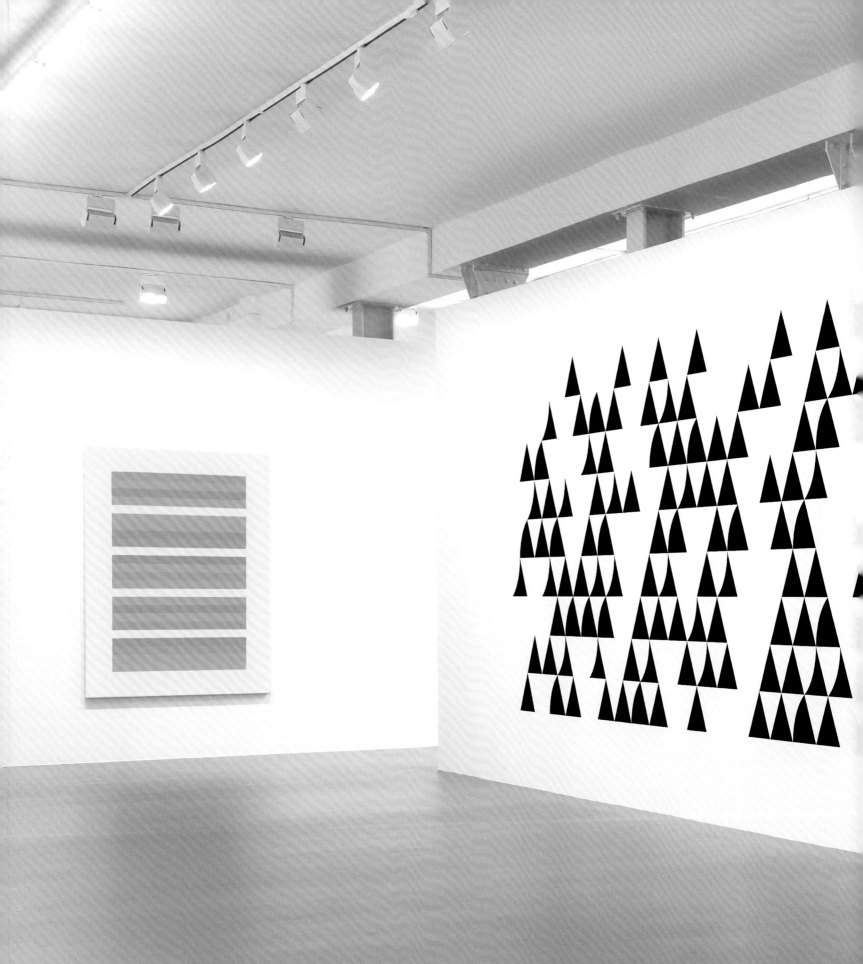

Installation view, Goethestraße 2/3, Berlin 2020: *Intervals* 1, 2019; *Quiver* 3, 2014; *Cascando*, 2015; *Vapour* 2, 2009

Quiver 3, 2014, graphite and acrylic paint on wall, 241 x 744 cm (94 ⁷/₈ x 292 ⁷/₈ inches) **37**

Vapour 2, 2009, acrylic on linen, 152.2 x 130 cm (59 $^{7}/_{8}$ x 51 $^{1}/_{8}$ inches)

Rustle 2, 2015, acrylic on APF polyester support, 196.5 x 196.5 cm (77 $^3/_8$ x 77 $^3/_8$ inches)

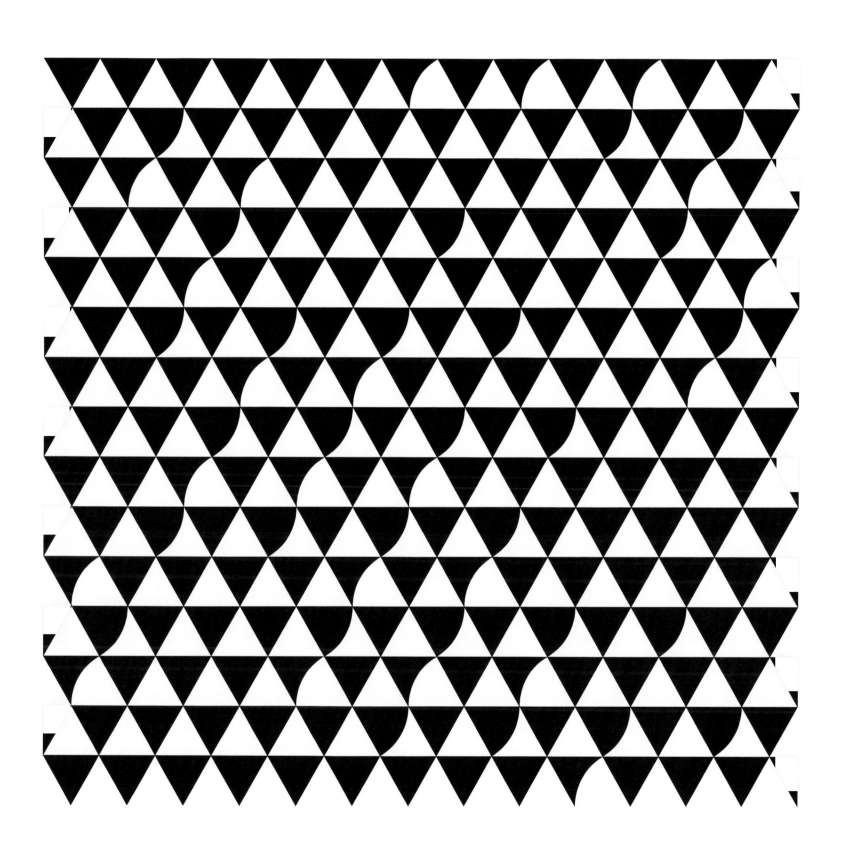

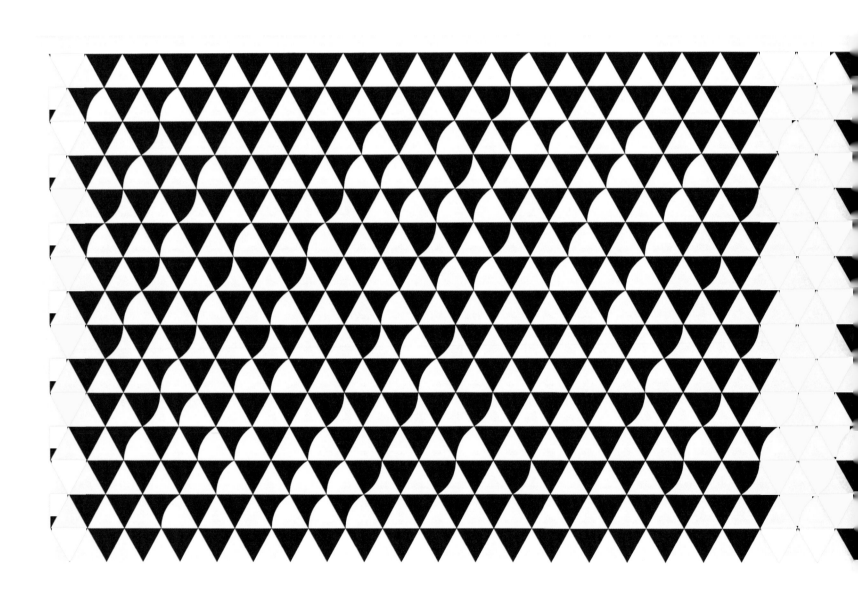

Cascando, 2015, acrylic on APF polyester support, 140.6 x 458.6 cm (55 ³/₈ x 180 ¹/₂ inches)

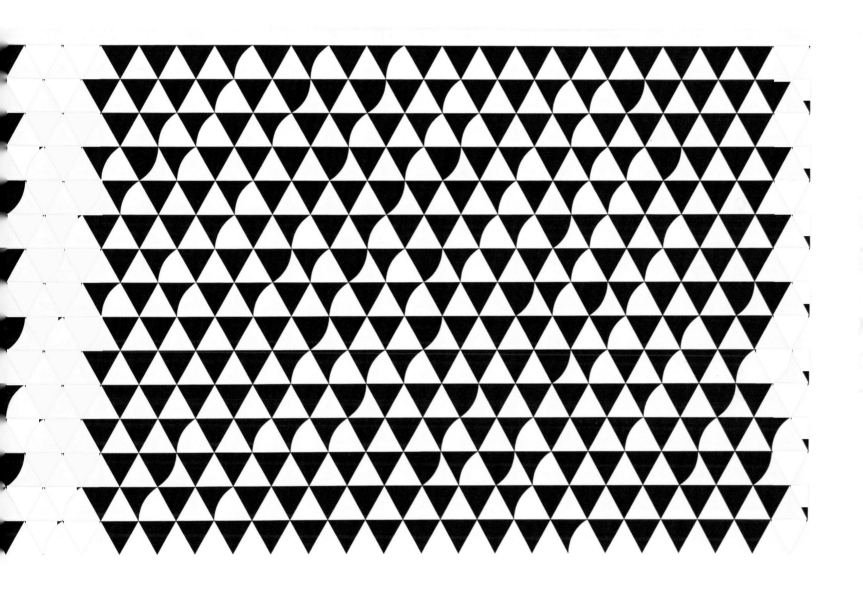

Installation views, Goethestraße 2/3, Berlin 2020: *Rustle 2*, 2015; *Measure for Measure 13*, 2017; *Study for Measure for Measure 13*, 2017

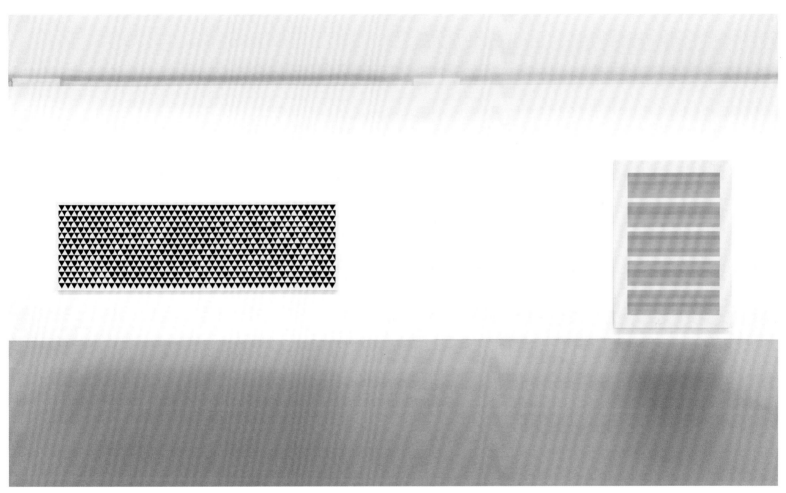

Cascando, 2015; *Intervals 8*, 2020

Study for Measure for Measure 13, 2017, acrylic on polyester, 64 x 63.5 cm (25 ¼ x 25 inches)

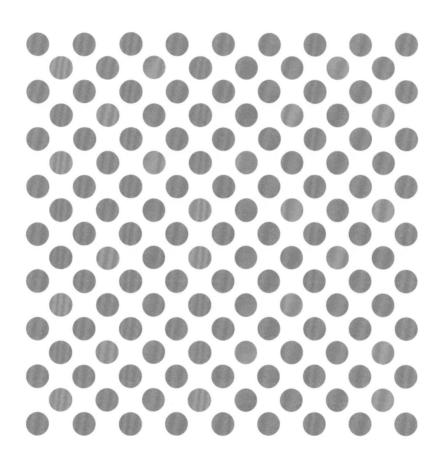

Measure for Measure 13, 2017, acrylic on canvas, 156.8 x 156 cm (61 $^{3}/_{4}$ x 61 $^{3}/_{8}$ inches)

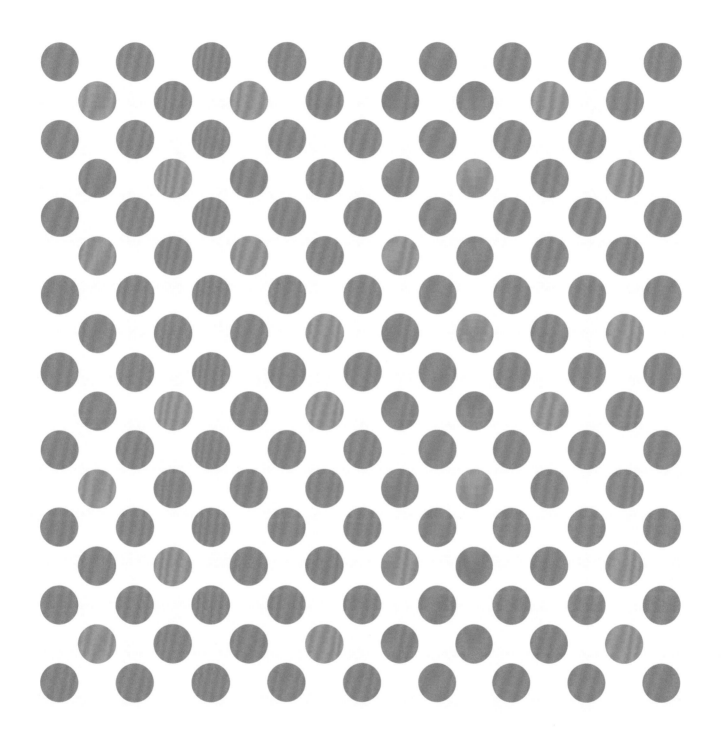

Measure for Measure 42, 2020, acrylic on linen, 120.7 x 229.8 cm (47 ¹/₂ x 90 ¹/₂ inches)

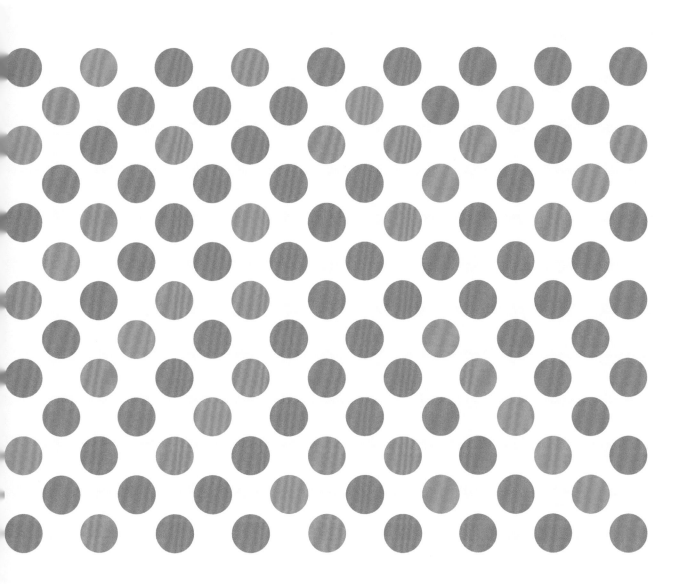

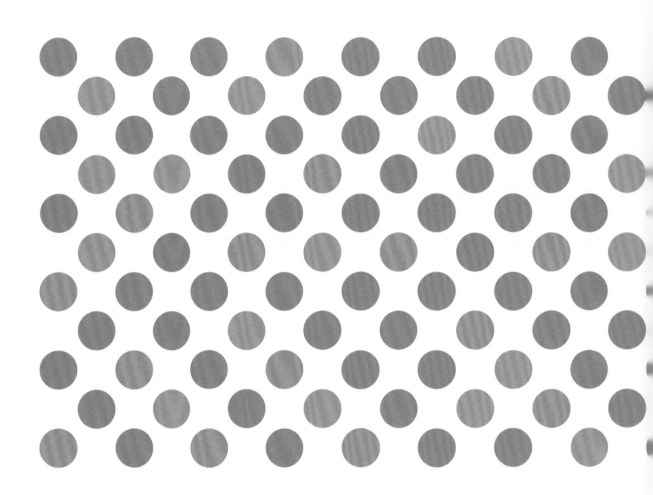

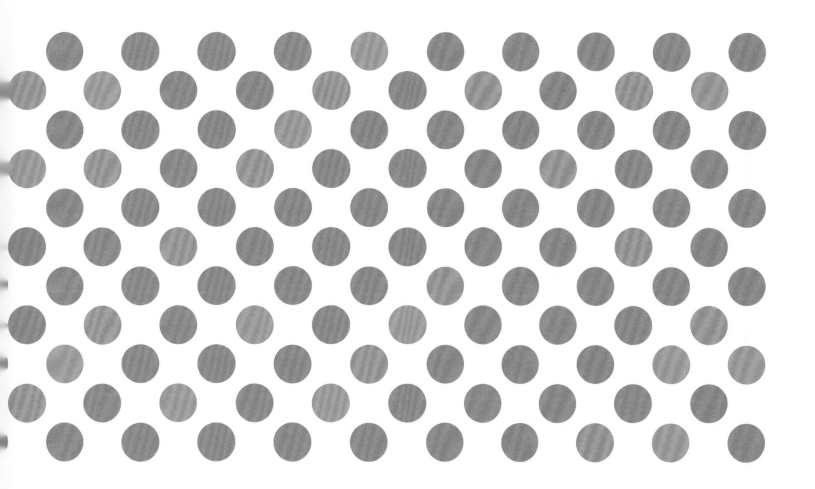

Installation views, Goethestraße 2/3, Berlin 2020: *Measure for Measure 42*, 2020; *Measure for Measure 13*, 2017

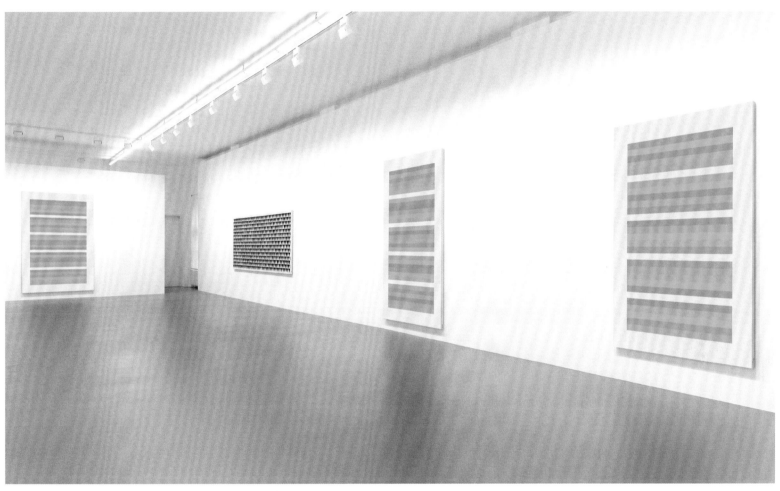

Intervals 7, 2020; *Cascando*, 2015; *Intervals 8*, 2020; *Intervals 9*, 2019

Intervals 1, 2019, oil on linen, 198.5 x 145.5 cm (78 $^1/_8$ x 57 $^1/_4$ inches)

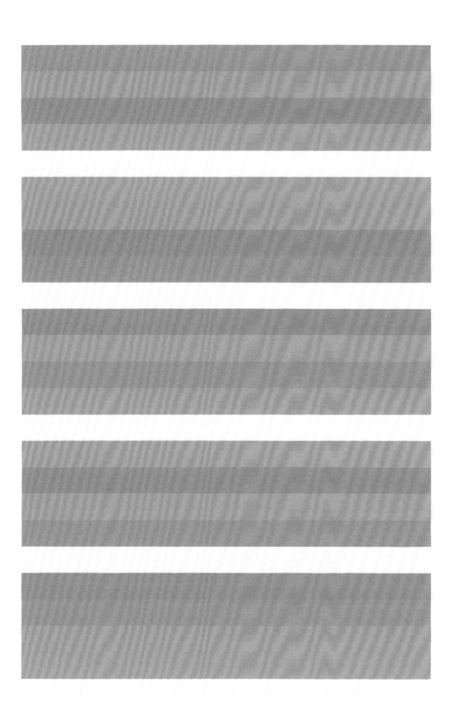

Intervals 7, 2020, oil on linen, 265 x 189cm (104 $^3/_8$ x 74 $^5/_8$ inches)

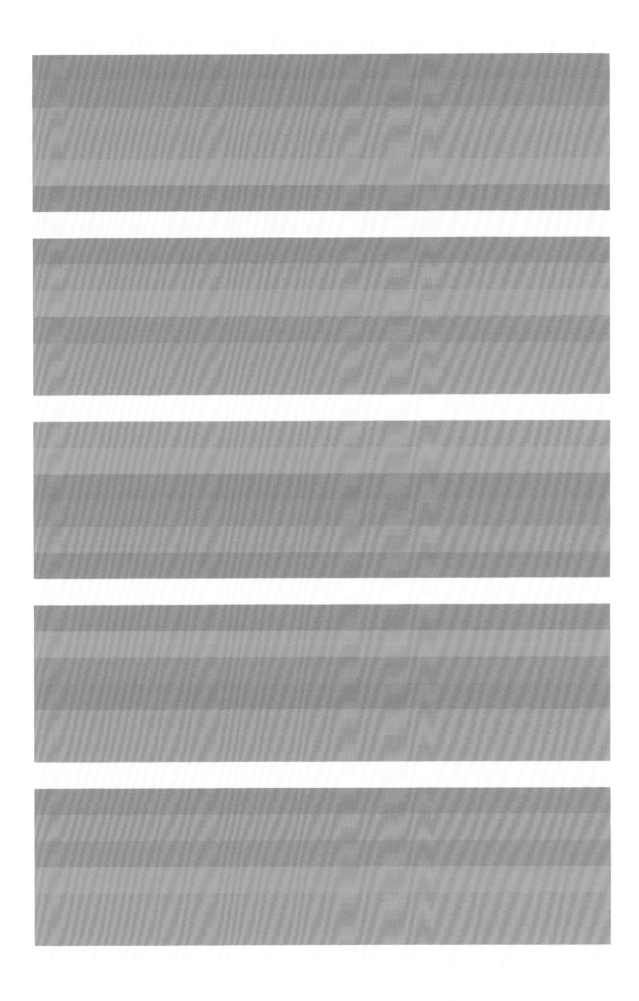

Intervals 8, 2020, oil on linen, 265 x 189 cm (104 $^3/_8$ x 74 $^3/_8$ inches)

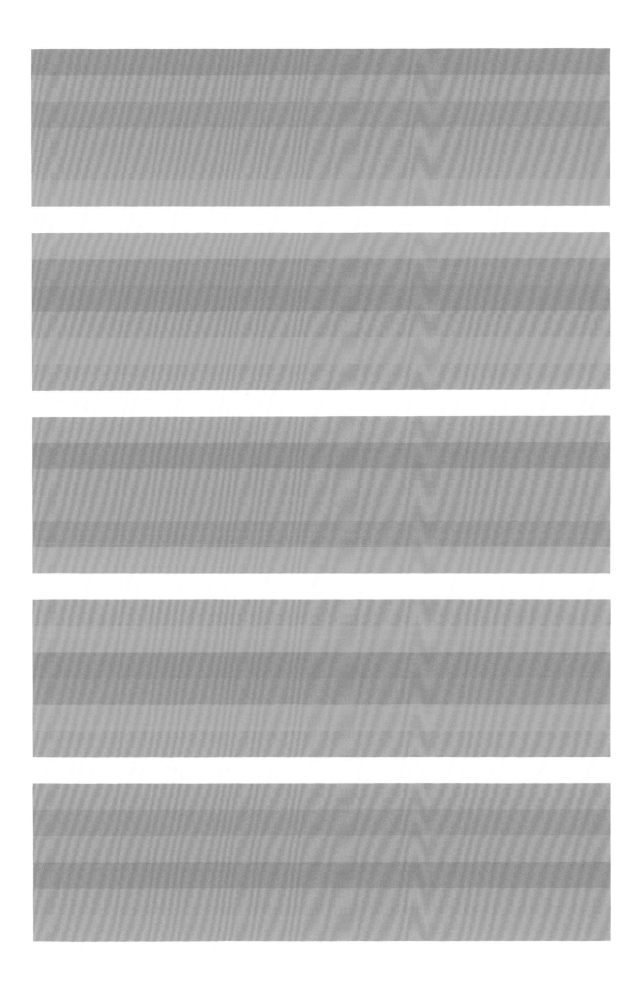

Intervals 9, 2019, oil on linen, 231 x 167.3 cm (91 x 65 $^7/_8$ inches)

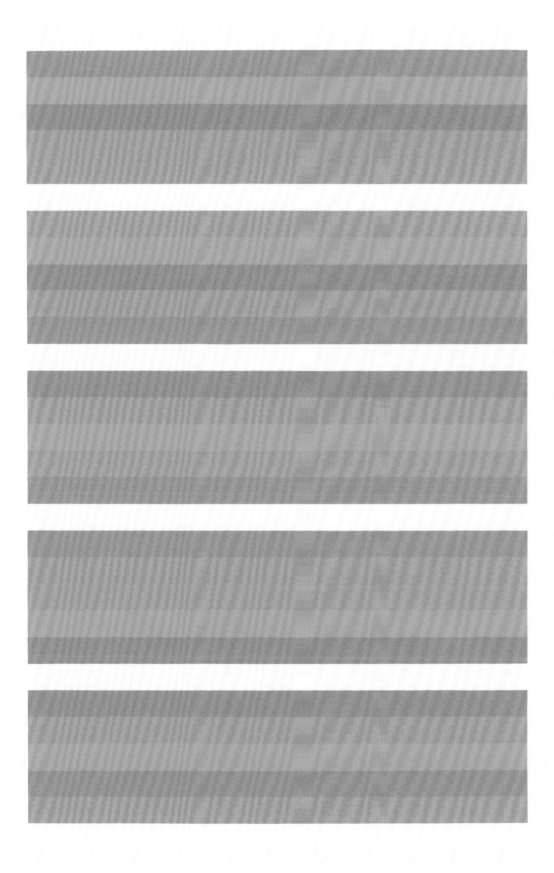

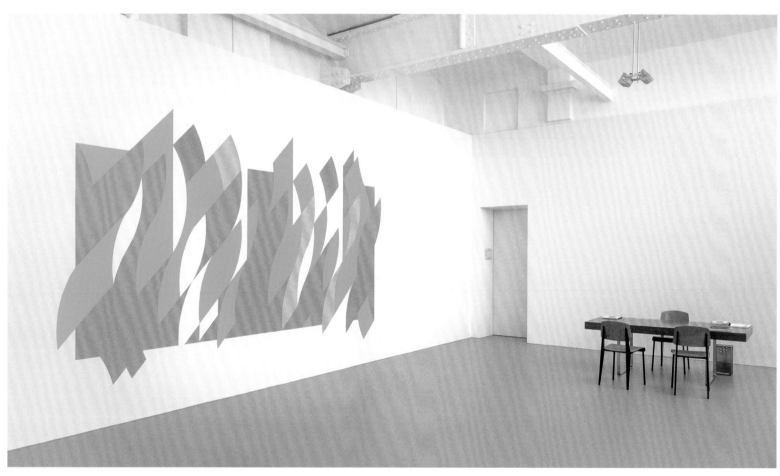

Installation view, *Bridget Riley*, Zimmerstraße 90/91, Berlin 2007

BIOGRAPHICAL NOTES

Robert Kudielka

1931

Bridget Riley is born in London.

1939–45

Childhood in Cornwall. While her father is away in the armed forces during the war she lives with her mother, younger sister and aunt (a former student of Goldsmiths College of Art, London) in a cottage not far from the coast near Padstow, where she develops an interest in nature. She receives an irregular primary education from non-qualified or retired teachers who from time to time assemble children in the locality for lessons in subjects in which they have some knowledge or interest.

1946–48

Education at Cheltenham Ladies' College. Thanks to an understanding headmistress, she is allowed to organise her own curriculum, and chooses only art lessons in addition to obligatory subjects. Her teacher, Colin Hayes, later tutor at the Royal College of Art, London, introduces her to the history of painting and encourages her to draw still life and from life. The van Gogh exhibition at the Tate Gallery in 1947 is her first encounter with the work of a modern master.

1949–52

Studies at Goldsmiths. For her entrance examination she submits, among other things, a copy of Jan van Eyck's *Portrait of a Man (Self Portrait?)* (otherwise known as *Man in a Red Turban*). She devotes herself mainly to the life-drawing class of Sam Rabin, who introduces her to the principles of pictorial abstraction: the autonomous construction of a body on a flat plane. Later, she affirms her respect for Rabin, saying: 'Life drawing was about the only thing I ever learned at art school.'

1952–55

Studies at the Royal College of Art. A period of great frustration, partly due to her limited experience of the London art scene, partly because she is yet to answer the unavoidable basic question of the modern painter: 'What should I paint, and how should I paint it?' Among her contemporaries are Frank Auerbach, Peter Blake, Robyn Denny, Richard Smith and Joe Tilson. She graduates with a BA degree.

1956–58

Continuation of a long period of distress. She nurses her father after a serious car accident and suffers a breakdown. She works in a glassware shop, teaches children and eventually joins the J. Walter Thompson advertising agency as a commercial illustrator, where her job is principally to draw the subjects that form the basis of the photographers' work. In the winter of 1958 she sees the Whitechapel Art Gallery's major Jackson Pollock exhibition, which makes a powerful impact.

1959

Stimulated by *The Developing Process* (April to May), the Institute of Contemporary Arts exhibition on the creative process devised by Harry Thubron and Victor Pasmore, she takes part in Thubron's summer school in Suffolk, where she meets Maurice de Sausmarez, who becomes her friend and mentor for the next few years and who will write the first monograph on her work (1970). The older painter and art scholar arouses her interest in Futurism and Divisionism and introduces her to primary documents of modern art (Klee, Stravinsky). In the late autumn, she copies Georges Seurat's *Le Pont de Courbevoie* (1886–87) from a reproduction.

1960

The first year of her independent work. In the summer she and Maurice de Sausmarez tour Italy, admiring the architecture. At the Venice Biennale, Riley sees a major exhibition of Futurism. In the hills surrounding Siena she makes studies for *Pink Landscape* (1960), a key painting in her early development. In the autumn, she breaks with de Sausmarez and suffers a personal and artistic crisis. From repeated attempts to make an entirely black painting, her first black-and-white works emerge, which she will continue to make until 1966; they are initially oriented towards contemporary hard-edge painting (e.g. *Kiss*, 1961) but very quickly take on the unmistakable traits of her own pictorial identity.

1961–64

A period of intense work, Riley begins the black-and-white paintings, which she continues until 1966. In London, one evening on her way home from J. Walter Thompson (where she works part-time until 1962), she shelters from a downpour in a doorway; it turns out to be the entrance of Gallery One, whose director, Victor Musgrave, asks her in. She invites him to visit her studio to look at her work. In the following spring of 1962, Musgrave holds her first solo exhibition. At this time Riley meets Peter Sedgley, a painter of her own generation, who becomes her partner during the 1960s. In the summer, they visit the plateau of Vaucluse in the south of France where she acquires a derelict farm, which in the 1970s is transformed into her new studio.

1965

Increasing recognition culminates in the inclusion of her work in the exhibition *The Responsive Eye* at the Museum of Modern Art, New York, in February. Richard Feigen Gallery, New York, simultaneously opens a solo show of her work that is sold out before the opening night. Josef Albers calls her his 'daughter' and Ad Reinhardt acts as her escort, to protect her from the 'wolves' of aggressively commercial New York. She has become a 'star', to whom even Salvador Dalí, together with his retinue (which includes real leopards), pays court. But her success is double-edged. Fashion-shop windows are full of 'Op' imitations of her work. With the help of Barnett Newman's lawyer, she tries to take legal action against this commercial plagiarism, only to discover that in the United States there is no copyright protection for artists. Leading New York artists, realising the dangerous implications of this, start their own independent initiative. As a result, in 1967 the first US copyright legislation is passed. Returning to London three weeks after the opening of *The Responsive Eye*, she has only one thought: 'It will take at least twenty years before anyone looks at my paintings seriously again.'

1965–67

A period of transition in which she introduces into her painting sequences of coloured greys, as opposed to the neutral greys she had used earlier, to create pictures of exceptional subtlety. These pictures, *Arrest* (1965), *Drift* (1966) and *Deny* (1966–67), carry further the method of reversal and compounding. In the summer of 1967, she visits Greece. In the same year, with *Chant* (1967) and *Late Morning* (1967–68), she makes her breakthrough to pure colour. Along with the sculptor Phillip King she is chosen to represent the United Kingdom at the forthcoming Venice Biennale. That winter she meets Robert Kudielka for the first time.

1968–69

Wins the International Prize for Painting at the 34th Venice Biennale in 1968. She is the first British contemporary painter and the first woman ever to achieve this distinction. It is also the last prize awarded by the Biennale in its old form. The prize-giving ceremony cannot take place due to student protests. Along with César, Marisol and others, she tries in vain to get into discussion with the students. In the autumn of the same year, she and Peter Sedgley establish SPACE, an organisation that provides artists with low-cost studios in large warehouse buildings. The project gets underway successfully at St. Katharine Docks in 1969 and still continues, with the support of Arts Council England, to the present day.

1970–71

A large European retrospective covering the period 1961–70 (including some work prior to 1961), showing the development from the black-and-white works to the new paintings based on the interplay of only two or three colours, opens at the Kunstverein in Hannover and subsequently travels to Bern, Düsseldorf, Turin and London, where it is extended and presented at the Hayward Gallery. It attracts more than 40,000 visitors. Robert Melville, who has so far followed her development rather critically, begins his review in the *New*

Statesman with: 'No painter, alive or dead, has ever made us more aware of our eyes than Bridget Riley.'

1971–73

The beginning of a period of radical artistic change. Her visits to museums and art galleries while accompanying her exhibition have made her more curious about the European tradition in painting. She undertakes numerous journeys with Robert Kudielka to see Tiepolo and Riemenschneider in Würzburg and Grünewald in Colmar; she visits the Alte Pinakothek in Munich, where she is deeply impressed by Altdorfer and Rubens, and the Prado in Madrid for the great Spanish painters and, above all, Titian. In such remote places as the Baroque churches of Upper Swabia she unexpectedly finds echoes of the luminous colours she is using at the time. All paths lead irresistibly and recurrently back to the vexing question occupying her in the studio: how to approach colour. At first, she tries to extend her means through formal changes, but with *Paean* (1973) she changes the formal organisation altogether, a move that anticipates the freer, more open structure of her work in the 1980s. In the spring of 1973, while looking at Altdorfer's cycle of the Passion in the convent of St. Florian near Linz, news reaches her that her mother is suffering from an acute form of myeloma.

1974–77

During the next two years she divides her time between London and Cornwall, to which her parents have retired. She begins to read Proust, who influences her on many levels. She has her property in Vaucluse renovated, but does not use the newly built studio until the beginning of the 1980s. With the 'curve paintings', on which she works exclusively between 1974 and 1978, her work takes a lyrical turn quite at odds with prevailing taste. Following the death of her mother in 1976, she concentrates on the preparation of another retrospective, and in this connection travels to Japan for three weeks at the end of March 1977, with a stopover in India (where she visits the cave temples of Elephanta, Ellora and Ajanta). Her spontaneous attraction to classical Japanese culture ranges from painting and formal gardens to Noh theatre and the hospitality of the ryokans. The gallery owner Shimizu enables her to gain entrance to almost all the important sites in and around Kyoto and Nara. At the Osaka Museum, she is given permission to study the famous sketchbook of Ogata Korin containing his drawings of waves.

1978–80

A second retrospective exhibition, with just under 100 paintings covering the years from 1959 to 1978, means that Riley travels extensively again. Opening in Buffalo, New York, in September 1978, it continues with two further stops in the United States, two in Australia, and reaches its final destination in Tokyo in January 1980. In December 1977, she has seen the exhibition *Cézanne: The Late Work* at the Museum of Modern Art, New York, now she visits the show again in Paris. In 1978, the exhibition *Monet's Years at Giverny: Beyond Impressionism* at the Metropolitan Museum of Art, New York, engages her to such an extent that she goes to see it a second time in the autumn in St. Louis. En route to the Sydney showing of her own

exhibition, she visits Tahiti. While in Australia she makes expeditions to the Barrier Reef, Alice Springs and Uluru/Ayers Rock. She returns home via Indonesia. In Bali, she enjoys the rich greens of the country and the extravagant colours of its festivals, especially the Barong theatre, and in Java she is particularly impressed by the pure, cool abstraction of the great temple of Borobudur in the middle of the jungle. Her artistic development takes an unexpected turn in the winter of 1979–80, when she travels to Egypt. There she is taken by the contrast between the cultivation in the Nile Valley and the monumental works of art on the edge of the desert. At the Cairo Museum, she is surprised by the consistent use of a certain group of colours in the arts and crafts of ancient Egypt; the tomb paintings on the West Bank of Luxor show her the full extent to which these colours could be developed. Later, after her return to London, she recalls the particular palette and begins considering its potential for her own work.

1981–85

The free reconstruction of the Egyptian palette gives her for the first time a basic range of strong colours, but their intensity demands a return to the simpler form of stripes. She begins to work regularly in her studio in Vaucluse and studies the use of colour by the French painters of classical modernism. In 1981, she is appointed a trustee of the National Gallery in London. In 1983, for the first time in 15 years, she visits Venice again to look at the paintings that form the basis of European colourism. She begins to give lectures on her work and accepts two commissions. In 1983, her wall decorations for the Royal Liverpool University Hospital are completed. In the same year, the Ballet Rambert gives a first performance at the Edinburgh Festival of the ballet *Colour Moves* (1983), created by the American choreographer Robert North in response to her backcloth designs. In the winter of 1981–82, she travels to southern India where she visits the major Hindu and Buddhist monuments. During the planning of the extension of the National Gallery, her role as a trustee becomes controversial. Almost single-handedly, she brings about the rejection of a commercial project for the new building and clears the way for the present Sainsbury Wing. In 1984, she gradually begins to prepare for a radical revision of her work in her Vaucluse studio, and in the spring of 1986 her painting takes a new direction.

1986–91

In 1986, on the occasion of an exhibition in New York, she meets two postmodern 'appropriation' painters, Philip Taaffe and Ross Bleckner, who have made extensive use of her earlier work. She herself is moving into a new area. The breaking up of the vertical register of her paintings through the introduction of a dynamic diagonal disrupts the balance of her pictorial space and results in larger and smaller units in lozenge form. In order to be able to concentrate fully on the new work, she sets up an additional studio in the East End of London. In summer 1989, the National Gallery invites Riley to select the latest in the series of *The Artist's Eye* exhibitions. She chooses seven large figure compositions by Titian, Veronese, El Greco, Rubens, Poussin and Cézanne from the museum's collection. They all have in common

an organisation shaped by diagonals and are characterised, if in varying degrees, by complex colour orchestrations.

1992–94

In spring 1992, a retrospective, *Bridget Riley: Paintings 1982–1992*, opens at the Kunsthalle Nürnberg and travels to the Josef Albers Museum Quadrat Bottrop, the Hayward Gallery, London, with the subtitle *According to Sensation*, and the Ikon Gallery, Birmingham. It consists of paintings that cover the transition from the stripe formations to the dynamism of the lozenge structures. The success of the show coincides, particularly in England, with a series of exhibitions focusing on the art of the 1960s. Riley emerges as one of the very few artists of that period who were subsequently able to develop their work. In 1994, the Tate Gallery in London puts on a Riley display, *Six Paintings 1963–1993*, drawn from its collection. As a result of the renewed interest in Riley's work, BBC Radio 3 produces a series of five programs in which Riley is in conversation with Neil MacGregor, E.H. Gombrich, Michael Craig-Martin, Andrew Graham-Dixon and Bryan Robertson. Broadcast in 1992, they are repeated the following year and published in book form in 1995. The same year, she delivers her lecture, 'Colour for the Painter', at Darwin College in Cambridge. Riley is made Honorary Doctor of the universities of Oxford (1993) and Cambridge (1995).

1995–98

Her painting *From Here* (1994) lends its title to an exhibition of three generations of British abstract painters, organised by Karsten Schubert and Waddington Galleries, London, in 1995. After a more than 30-year absence from teaching, Riley accepts an invitation to join the staff of De Montfort University, Leicester, as visiting professor. In 1996, she gives the 23rd William Townsend Memorial Lecture at the Slade School of Fine Art, London, choosing 'Painting Now' as the subject. Visits to the Mondrian retrospective at the Gemeentemuseum in The Hague in the winter of 1994–95 lead to an intense re-engagement with the Dutch artist's work and writings. In November 1995, she contributes a paper to a Mondrian symposium at the Museum of Modern Art, New York. The following year, she is asked by the Tate Gallery to select a Mondrian exhibition from the collection of the Gemeentemuseum. Installed by Riley and her co-curator Sean Rainbird, the exhibition is the first comprehensive Mondrian show in England for 40 years. Meanwhile, her own work is showing signs of further change. Having slowly introduced colour harmonies equal to the prevailing contrast structure, she is now working with a new sensation of 'depth'. In spring 1997, she also begins to introduce circular or curvilinear forms into her developed rhomboid structures, to facilitate the looping arc-like movements of the colour organisation. The renewed preoccupation with curves, and her interest in deep but not illusionistic pictorial space, leads to a large temporary wall drawing, *Composition with Circles 1* (1997), carried out for the *White Noise* exhibition at the Kunsthalle Bern in May 1998. The sensation of layered planes, previously achieved through complex colour relationships, is here the result of simple black-and-white drawing. The wall drawing has a major effect on her colour work. The first

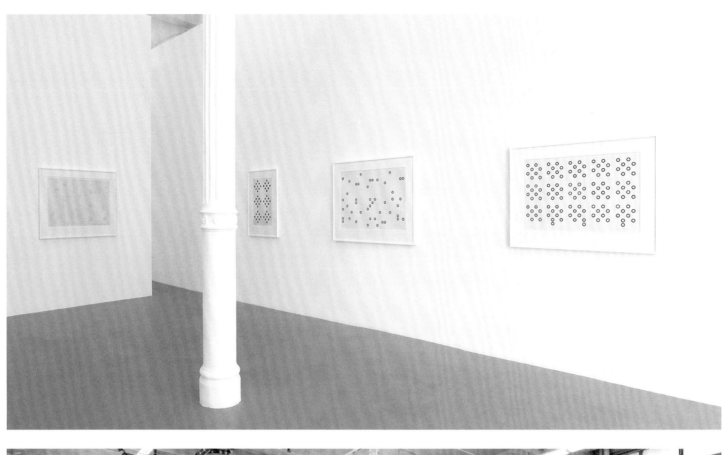

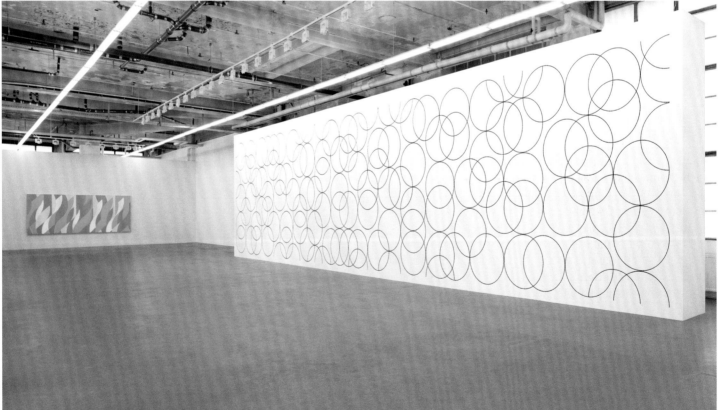

Top: Installation view, *Bridget Riley: Circles Colour Structure Studies* 1970/71, Zimmerstraße, Berlin 2009. Bottom: Installation view, *Bridget Riley: Paintings and Related Work 1983–2010*, Oudenarder Straße 16–20, Berlin 2011

results of this development are included in the exhibition *Bridget Riley: Works 1961–1998* shown at the Abbot Hall Art Gallery, Kendal, in winter 1998–99.

1999–2000
In the 1999 New Year's Honours, Riley is appointed Companion of Honour. In June, the exhibition *Bridget Riley: Paintings from the 1960s and 70s* opens at the Serpentine Gallery, London; on this occasion, the first edition of *The Eye's Mind: Bridget Riley, Collected Writings 1965–1999* is published. In October, the exhibition *Bridget Riley: Selected Paintings 1961–1999* is shown at the Kunstverein in Düsseldorf. The show makes a connection between the early black-and-white painting *Kiss* (1961) and *Rêve* (1999), her first fully achieved painting using the new curvilinear rhythm. In spring 2000, her biggest architectural commission to date is completed: a hanging, curtain-like installation, *Citibank Installation (Curtain)* (2000), in the atrium of Citibank's European headquarters in London designed by Norman Foster + Partners. Extending over 15 floors (more than 40 metres), it consists of three planes of coloured aluminium plates suspended by steel cables. Although related to her rhomboid paintings, this open construction changes according to the viewpoint from which it is seen and the conditions of light in the office tower. In the summer, a group of her new curve paintings and related works on paper is shown in London for the first time at Waddington Galleries, an exhibition organised by Karsten Schubert. In the autumn, the Dia Center for the Arts in New York mounts a survey of her work under the title *Bridget Riley: Reconnaissance*. The exhibition is complemented by a show of recent paintings at PaceWildenstein. Both shows mark a major re-evaluation of her work in America. At the end of November, she takes part in the international symposium 'Das Bild: Image, Picture, Painting' at the Akademie der Künste in Berlin.

2001–02
In collaboration with Robert Kudielka, Riley prepares a Paul Klee exhibition for the Hayward Gallery, London. She participates in the Santa Fe Biennial, *Beau Monde 2000: Toward a Redeemed Cosmopolitanism*, curated by Dave Hickey, with the painting *Evoë 1* (2000). The exhibition *Paul Klee: The Nature of Creation* is shown at the Hayward in the spring of 2002. In March, *Bridget Riley: New Work* opens at the Museum Haus Esters and the Kaiser Wilhelm Museum, Krefeld, the first museum show dedicated exclusively to the new curvilinear paintings. An extended German version of *The Eye's Mind: Bridget Riley* is published under the title *Malen um zu sehen: Bridget Riley*.

2003
The year 2003 is dominated by the preparation and installation of Riley's retrospective exhibition at Tate Britain (June to September). Together with curator Paul Moorhouse she selects 56 paintings from all periods since 1961 and a group of preparatory studies that give an insight into her working methods. For the exhibition, she makes a special wall drawing, *Composition with Circles 3* (2003), that links the early black-and-white work with her most recent paintings. The show receives universal critical acclaim and draws 98,000 visitors. In September, Riley is awarded the Praemium Imperiale by the Japan Art Association for her lifetime's achievement as a painter. She travels to Tokyo for the official award ceremony and delivers a message of thanks on behalf of the other laureates (Mario Merz, Ken Loach, Claudio Abbado and Rem Koolhaas). During this trip, she revisits some of the masterpieces of ancient Japanese art in Tokyo and Kyoto.

2004–05
A new retrospective exhibition travels to Australia and New Zealand. It is first shown at the Museum of Contemporary Art in Sydney and later at the City Gallery Wellington. In modified form, the exhibition is later presented at the Aargauer Kunsthaus in Aarau, Switzerland. A small survey is shown at the Cranbrook Art Museum in Bloomfield Hills, Michigan. Riley continues to develop her work steadily in the studio. Among the new works exhibited in autumn 2004 at PaceWildenstein in New York is *Painting with Two Verticals* (2004), where for the first time the dynamism of the curves is both countered and enhanced by vertical divisions. For the rebuilt home of the Akademie der Künste in Berlin (of which she becomes a member in 2004), Riley makes another wall drawing, *Composition with Circles 5* (2005). Her work continues to be included in the growing number of historical surveys covering the optical and kinetic tendencies in 20th-century art. The environment *Continuum* (1963/2005), which was part of her second solo exhibition at Gallery One, London, is reconstructed for the exhibition *L'œil moteur: Art optique et cinétique 1950–1975* at the Musée d'Art moderne et contemporain, Strasbourg. In April 2005, Riley delivers the Seamus Heaney Lecture at Dublin City University on the subject of 'Working'.

2006–07
The year 2006 is characterised by intense work in the studio, which by the autumn leads to an unexpected new departure. Riley discovers that preparatory work with cut-out papers allows her to open up the rectangular picture format, thereby making the white wall an integral part of the field. She explores the potential of this discovery in several studies and finally in *Wall Painting 1* (2007; later called *Arcadia 1*), which is first shown in 2007 at Galerie Max Hetzler in Berlin and subsequently at PaceWildenstein, New York, in a double show of new works in both the gallery's uptown and downtown branches. At the same time, the Museum of Modern Art presents the exhibition *Georges Seurat: The Drawings*, to which Riley contributes a catalogue essay, 'Seurat as Mentor', in which she acknowledges her indebtedness to the work of the French artist. The coincidence of the Museum of Modern Art and PaceWildenstein exhibitions prompts the critic of *The New York Times* to express doubt about the conventional assessment of Riley's work in current art history: 'More and more, however, Ms. Riley comes across less as an Op artist than as the last living Post-Impressionist.'

2008
In June, the largest-ever Riley retrospective exhibition opens at the Musée d'Art moderne de la Ville de Paris. Fabrice Hergott, the director of the museum, calls it a 'historic event' not only because it is the

first comprehensive show of Riley's work in France but, more importantly, because it is a homage to the historical roots of her art. Selected by Anne Montfort in collaboration with the artist, the exhibition consists of 56 paintings and about 80 drawings covering her development from the early pointillist work in the 'method' of Seurat to the most recent curve paintings. For the long, curved room in the museum, Riley creates *Composition with Circles 6* (2008), by far the largest work of this kind. Also included in the exhibition is *Arcadia 1 (Wall Painting 1)* (2007). In addition to a substantial catalogue, the exhibition is accompanied by a French translation of her collected writings, *L'Esprit de l'œil: Bridget Riley*.

2009

In the winter of 2008–09, Karsten Schubert shows *Bridget Riley: Circles, Colour, Structure: Studies 1970/71*, a never-before-exhibited group of studies executed in 1970–71. The show subsequently travels to Galerie Max Hetzler in Berlin, where the critics are amazed by the freshness and vitality of the work: 'Bridget Riley is undoubtedly a classic whose early power of creation continues to the present day.' In July, Riley receives the Award of Companionship of De Montfort University, Leicester. *Bridget Riley: Flashback*, a UK touring exhibition of Riley's paintings and studies from the Arts Council Collection, opens at the Walker Art Gallery, Liverpool, in September. During October, Riley is awarded the Kaiserring of the town of Goslar. First given to Henry Moore in 1975, it is Germany's most prestigious international art prize. It is accompanied by a retrospective exhibition at the Mönchehaus Museum (2009–10). A second, revised and enlarged edition of *The Eye's Mind: Bridget Riley* is published by Thames & Hudson and Ridinghouse. The year ends with an exhibition of new paintings and wall paintings held in conjunction with Karsten Schubert at the Timothy Taylor Gallery in London.

2010

Flashback continues, traveling to Birmingham Museum and Art Gallery, Norwich Castle Museum and Art Gallery and Southampton City Art Gallery. Riley's interest in the fundamental role of drawing, revived by her essay 'Seurat as Mentor' (2007), leads to two events. In May, a display of her portrait drawings from the mid-1950s is installed at the National Portrait Gallery, London, which continues into 2011. It generates considerable interest across a wide public and is accompanied by a catalogue titled *From Life*, with autobiographical recollections by the artist and an essay by Paul Moorhouse. Riley's belief in the formative importance of such experience is revealed in 'Learning to Look', a talk that she gives at the British Museum, London, in May as part of the evening lecture program supporting the exhibition *Italian Renaissance Drawing*. In November, the exhibition *Bridget Riley: Paintings and Related Work* opens in the Sunley Room at the National Gallery, London. It combines exemplary paintings and studies from the years 1962–2010 with recent wall works, and is supplemented by a small group of works from the museum's collection, specially chosen by the artist for this occasion: a processional scene by Mantegna, Raphael's *St. Catherine of Alexandria* (1507) and some of Seurat's studies for the *Bathers at Asnières* (c. 1884).

2011

In January, it is announced that Riley will be the recipient of the Rubens Prize 2012. Initiated in 1955 by the city of Siegen (South Westphalia – the birthplace of the great Baroque painter – the prize is awarded every five years, and over the decades has been given to a number of outstanding painters (Giorgio Morandi, Francis Bacon, Antoni Tàpies, Cy Twombly, Sigmar Polke et al.). In February, the exhibition *Bridget Riley: Paintings and Related Work 1983–2010* opens at Galerie Max Hetzler in Berlin. The extensive exhibition is the first to concentrate exclusively on her colour work since the 1980s and includes both paintings and wall drawings. Riley also shows the new paintings with vertical stripe formations that resulted from her re-engagement with the structure of the Egyptian colours, developing an increased depth and chromatic intensity. In late autumn, a similar range of work, though on a more intimate scale, is presented at Kettle's Yard in Cambridge under the title *Bridget Riley: Colour, Stripes, Planes and Curves*. Earlier, in June, Riley, as a member of the Akademie der Künste, travels to Berlin for the exhibition of Gina Burdass, whom she has selected for the Akademie's exhibition series *Ausgewählt* (Artist's Choice). On this occasion, her temporary wall drawing for the Akademie, *Composition with Circles 5* (2005), is uncovered for the last time, before its removal due to construction work. In October, the Riley Art Foundation (Bridget Riley Art Foundation since 2013) is established as a charity for the advancement of the arts and 'education in the arts, in particular in abstract art and its interaction with Renaissance art and Impressionism, as articulated by the works of Bridget Riley'. Karsten Schubert in London presents *Bridget Riley: Paintings and Gouaches 1979–80 & 2011*. The exhibition combines a group of subtle colour studies for the *Song of Orpheus* series (1978) with new paintings in which she attempts to recreate within the rectangle of the canvas certain aspects of the experience provided by the black-and-white wall drawings. In these works, the spatial depth is generated by superimposing two pale yellows on a white ground.

2012

In May, two London galleries, Hazlitt Holland-Hibbert and Karsten Schubert, jointly present *Bridget Riley: Works 1960–1966*. Riley contributes the screenprint *Rose Rose* (2011) to *London 2012*, a portfolio published in celebration of the Olympic Games. In July, she receives the Rubens Prize; at the ceremony, Lucius Grisebach gives the encomium. Concurrently the exhibition *Bridget Riley: Malerei/Painting 1980–2012* opens at the Museum für Gegenwartskunst Siegen, which besides *Arcadia 1 (Wall Painting 1)* (2007) includes a large new wall painting, *Rajasthan (Wall Painting)* (2012). In October, she travels to Budapest for the exhibition *Cézanne and the Past* at the Museum of Fine Arts. Along with her enduring interest in Cézanne, she is also intrigued by the exhibition's subtitle, *Tradition and Creativity*, a subject with which she has been increasingly engaged. In October, Riley is awarded the Sikkens Prize in The Hague. First given to Gerrit Rietveld in 1959, the prize is bestowed on artists for outstanding achievements in the field of colour. Riley is the first woman artist to

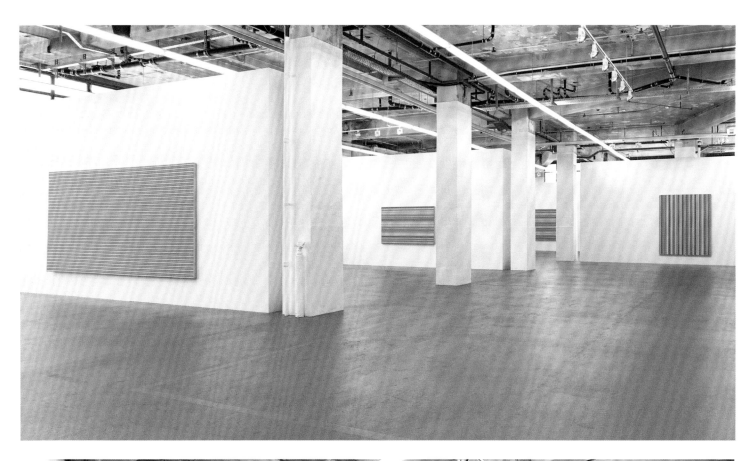

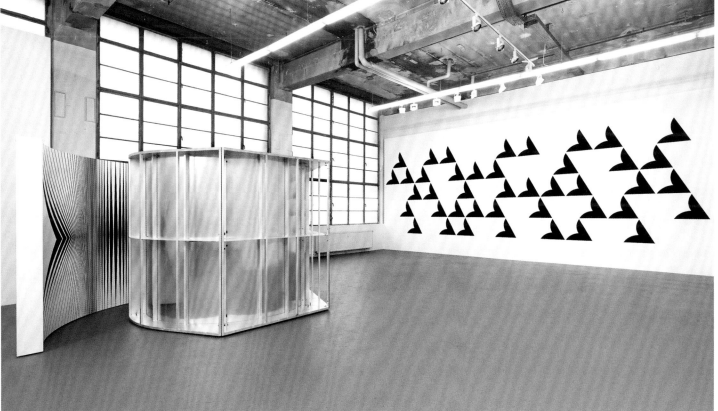

Top: Installation view, *Bridget Riley: Die Streifenbilder / The Stripe Paintings 1961–2012*, Oudenarder Straße 16–20, Berlin 2013. Bottom: Installation view, *Remember Everything. 40 Years Galerie Max Hetzler*, Oudenarder Straße 16–20, Berlin 2013

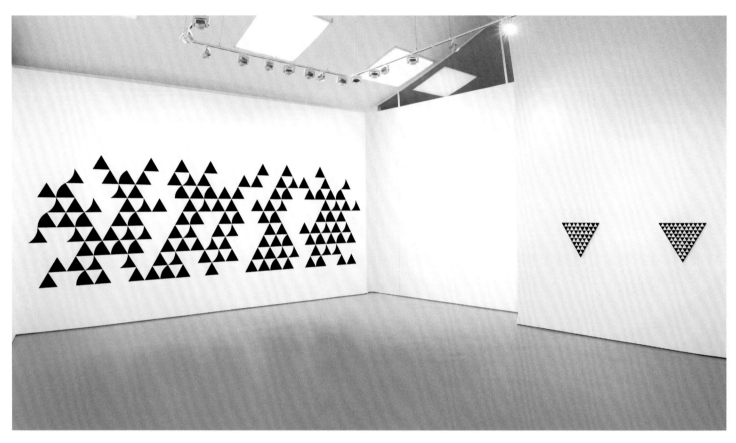

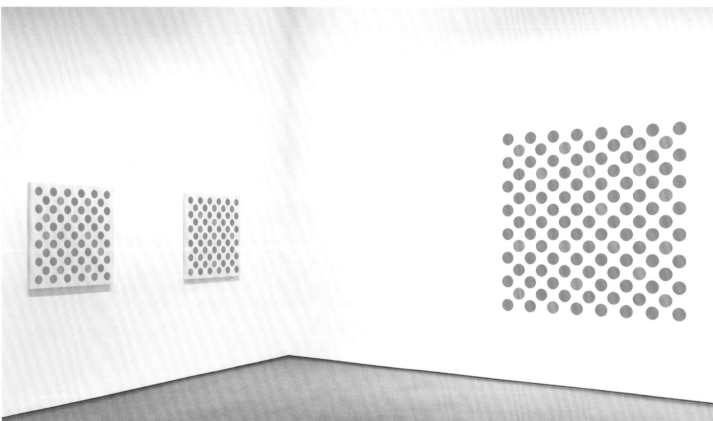

Top: Installation view, *Bridget Riley*, 57, rue du Temple, Paris 2015. Bottom: Installation view, *Bridget Riley: Measure for Measure. New Disc Paintings*, 57, rue du Temple, Paris 2017

receive this prize: 'The purity, subtlety and precision of her use of colour have led to a sensational oeuvre from which a generation of artists is drawing inspiration.' John Elderfield delivers the encomium. Simultaneously, the Gemeentemuseum presents a small exhibition of Riley's works in the immediate vicinity of its permanent collection of Mondrian and De Stijl. At the center of the Riley display is a large new wall drawing, *Composition with Circles 9* (2012).

2013

In early 2013, Riley becomes a patron of the charity Art in Hospitals, part of the Imperial College Healthcare Charity. She has been engaged since 1987 with wall decorations for St. Mary's Hospital in Paddington, London, and in March 2014 an additional corridor design is installed and opens to the public. Intense work in the studio during the previous year results in the completion of a group of horizontal paintings that evolve from her reintroduction of the stripe element in 2011. Carrying *Rose* or *Red* in their titles, these new paintings stand at the centre of the exhibition, *Bridget Riley: Die Streifenbilder / The Stripe Paintings 1961–2012*, which opens at Galerie Max Hetzler in Berlin in June 2013. Starting with *Horizontal Vibration* (1961), the selection gives an exemplary survey of Riley's ongoing involvement with this form. In the summer, the Kunsthalle Bielefeld shows Riley's wall painting *Rajasthan (Wall Painting)* (2012) as part of the exhibition, *For the Time Being: Wall Paintings – Painted Walls*. In September, Riley attends the private view of *Im neuen Glanz / In New Splendour*, the rehang of the collection of the Staatsgalerie Stuttgart by the new director, Christiane Lange. It includes a room devoted to Riley's big colour paintings. In the autumn, as part of the Galerie Max Hetzler's 40th anniversary exhibition *Remember Everything* in Berlin, she shows a new wall painting, *Quiver 2* (2013), based on her re-engagement with her early black-and-white painting *Tremor* (1962).

2014

In January, the wall painting *Quiver 1* (2013), commissioned by the Museum für Gegenwartskunst Siegen, is permanently installed in the museum's lobby. In the Print and Drawing Room of the British Museum London, the project 'Drawing from Drawing', funded by the Bridget Riley Art Foundation, begins. Attendance at the two-year workshop aimed at encouraging art students to learn through copying works from the collections surpasses all expectations. During her annual spring trip to France, Riley visits the newly opened Fondation Vincent van Gogh in Arles. In June, the exhibition *Bridget Riley: The Stripe Paintings 1961–2014* opens at David Zwirner, London, in collaboration with Karsten Schubert. On the occasion of *Matisse: The Cut-Outs* at Tate Modern, London, Riley gives a talk on the artist's late work. In November, she delivers the A. James Speyer Memorial Lecture on 'Learning to Look' at the Art Institute of Chicago. Concurrently the museum opens a display that includes *Ascending and Descending Hero* (1963/1965) from its own collection, *Continuum [Reconstruction]* (1963/2005), *Horizontal Vibration* (1961) and a recent horizontal stripe diptych, *Red Modulation (Yellow and Orange)* (2014). The winter is spent in her London studios developing a body of work that evolved from the first two *Quiver* wall paintings (2013).

2015

The new black-and-white paintings, based on an equilateral triangle partly modified by a curved side, are first exhibited in May 2015 at Max Hetzler's new Paris gallery. During the summer, the De La Warr Pavilion in Bexhill on Sea, one of the outstanding monuments of 1930s modernist architecture in the United Kingdom, shows *Bridget Riley: The Curve Paintings 1961–2014*. Riley receives a medal from the trustees and the director of the British Museum in 'gratitude and admiration' of her commitment to the museum as a world of understanding. In September, the Courtauld Gallery, London, presents *Bridget Riley: Learning from Seurat*, a small exhibition showing her 1959 copy after George Seurat's painting *Le Pont de Courbevoie* along with the original from the gallery's collection. Far from suggesting any direct comparison between the two, she selects seven paintings that show the pivotal importance of Seurat's thinking in the formation of her own abstract work. In November, David Zwirner, New York, opens an exemplary overview of her work from 1981 to 2015. Picking up from *Reconnaissance* at the Dia Center for the Arts in 2000, this exhibition covers the broadening range of Riley's pictorial interests from her development into colour to her renewed preoccupation with the black-and-white contrast.

2016

The year commences with a series of retrospective exhibitions devoted to certain aspects of Riley's work. At the beginning of February, she attends the opening of *Eye Attack: Op Art and Kinetic Art 1950–1970* at the Louisiana Museum, Humlebaek, 'the first major presentation of Op Art and kinetic art in Scandinavia for more than fifty years', according to the catalogue. Riley's work plays a prominent role in this comprehensive survey with nine paintings, including *Current* (1964) from *The Responsive Eye* exhibition. Later this month, the Graves Gallery in Sheffield opens *Bridget Riley: Venice and Beyond, Paintings 1967–1972*, a small but concentrated show focusing on the stripe painting *Rise 1* (1968) from its own collection within the context of the early development of her colour work. In April, *Bridget Riley: Paintings 1963–2015* starts at the Scottish National Gallery of Modern Art in Edinburgh. Scheduled for one year, this display comprises selected works from all periods providing the opportunity to see the recent black-and-white work together with her early ground-breaking paintings, and both developments in relation to her lasting preoccupation with colour. In June, the Gemeentemuseum, The Hague, presents an enlarged version of the De La Warr exhibition, *Bridget Riley: The Curve Paintings 1961–2014*. After a delay due to technical difficulties in fabrication, Riley's first stained glass window *Dance* (2016), based on the black-and-white movement of the *Quiver* wall paintings (2013–14), is installed in the museum and inaugurated in November.

2017

In the spring, the book *About Bridget Riley: Selected Writings 1999–2016*, an extensive collection of essays on Riley's work by an international range of authors, is published. In March, Robert North, now Director of Ballet at the Theater Krefeld-Mönchengladbach,

revives the ballet *Colour Moves*, which he created in 1983 in response to Riley's backdrops, under the German title *Farbenspiel*. In June, an exhibition related to the Courtauld show *Learning from Seurat* (2015–16) accompanies the installation of the wall painting *Cosmos* (2017) in Christchurch Art Gallery Te Puna o Waiwhetu, New Zealand. The acquisition of this work fulfilled a long-cherished wish of the director of the museum, Jenny Harper, who had started her career by writing a thesis on Riley in the early 1980s at the Courtauld Institute in London, and played a major role in the seismic strengthening and reopening of the building after the Canterbury earthquakes of 2010–11. With *Cosmos* a new theme that the artist has been pursuing since the autumn of 2015 makes its first public appearance: discs in three muted colours reminiscent of the greyed purples, greens and ochres in *Vapour* (1970) give rise to a pulsating rhythmic field that opens up an indeterminate sensation of depth and expanse. The paintings related to this wall work are titled *Measure for Measure* and shown first in October in the Galerie Max Hetzler in Paris. In the same month Riley contributes the highlight to Chinati Weekend 2017 at Marfa, Texas. In the Special Exhibition Gallery of the Chinati Foundation, a wall painting (*A Bolt of Colour*, 2017) recalling her decoration for the Royal Liverpool University Hospital (1983, now removed due to reconstruction) spans the entire U-shaped space. Radiating in the colours of her 'Egyptian palette', it reinvokes for two years the spirit with which Chinati's founder Donald Judd intended to endow this place: bringing art, architecture and nature together in a mutual dialogue.

2018

Due to support from the Bridget Riley Art Foundation the new Goldsmiths Centre for Contemporary Art and the South London Gallery can establish gallery spaces named after the artist. Riley herself is preparing a number of exhibitions. In January, David Zwirner, London, opens *Recent Paintings 2014–2017*, a show that brings together her new black-and-white work with the *Measure for Measure* series, both of which include wall paintings. In April, the Kawamura Memorial DIC Museum of Art in Japan holds the exhibition *Paintings from the 1960s to the Present*, which focuses on the stripe and curve paintings. It draws on holdings from seven prefectural museums and is complemented by loans from British institutions and private collectors. The five-volume catalogue *Bridget Riley: The Complete Paintings 1946–2017*, which was begun in 2016, is published by the Bridget Riley Art Foundation and Thames & Hudson in June. In October, she takes part in *Unexpected View*, an event arranged by the National Gallery, London, and Frieze Art Fair, talking to Gabriele Finaldi about John Constable's *Weymouth Bay: Bowleaze Cove and Jordon Hill* (1816). In November, *Painting Now* opens at Sprüth Magers in Los Angeles. A survey of Riley's work from the 1960s to the present, it takes its title from her William Townsend Memorial Lecture at the Slade in 1996 in which she argued the undiminished capacity of painting to articulate our sensations, feelings and spiritual aspirations. In mid-December preparations start for the installation of a new large-scale wall painting in the Annenberg Court of the National Gallery, London. The site

requires extensive scaffolding, and the execution of the work is carried out by a team of her assistants led by Hamilton Darroch.

2019

On the 17th of January the wall painting *Messengers* is unveiled at the National Gallery. Spanning altogether approx. 10 x 20 metres (32 x 65 feet), a constellation of coloured discs is painted directly onto the white surface of the south and west walls of the Annenberg Court. Its title is inspired by Constable's description of a certain cloud formation: 'They [the "messengers"] float about midway in what may be termed lanes of clouds… In passing over the bright parts of large clouds, they appear as "darks"; but in passing the shadowed parts they assume a grey, a pale, or lurid hue.' In June the National Galleries of Scotland present the first comprehensive exhibition of Riley's work in the United Kingdom since the Tate retrospective in 2003. Covering 70 years it traces the continuity of her development beginning with early figurative work and leading up to her latest wall paintings. In the autumn the exhibition that had its premiere showing at the Royal Scottish Academy in Edinburgh travels to the Hayward Gallery, London, where additional wall works are included. Concurrently, a third, augmented edition of *The Eye's Mind* and a third edition of *Dialogues on Art* are published.

2020

In January, Riley's retrospective exhibition at the Hayward closes, attended by more than 110,000 visitors. In the studio she continues to develop the *Measure for Measure* series, in addition to a new intervallic theme introduced in 2019. A muted colour range of off-purple, off-green and off-orange in different degrees of tonality is employed in both groups of paintings. At the beginning of March the David Zwirner Gallery in London opens an exhibition that combines a selection of studies for the 'rhomboid' paintings from the years 1984–1997 with a group of late works by Paul Klee, of whom Riley has said: 'He showed me what abstraction meant.' Due to the outbreak of the COVID-19 pandemic she shortens her customary working visit to the South of France, returning to work in isolation in her West London studio, while her studio assistants take a temporary leave of absence. Despite the grave pandemic restrictions, two important exhibitions can take place in the autumn. In mid-September the Cristea Roberts Gallery in London opens the survey *Bridget Riley: Prints 1962–2020*, on the occasion of which the catalogue raisonné *Bridget Riley: The Complete Prints 1962–2020* (Bridget Riley Art Foundation and Thames & Hudson, 2020), is published. In Berlin, Max Hetzler opens an exhibition across all three of his galleries which, due to COVID-19 restrictions, the artist is unable to attend. Eighteen works are shown that represent the stage-by-stage evolution of their association since 2007, starting with the wall painting *Arcadia 1* (2007), leading through the horizontal stripe paintings dominated by the colour red and closing with the recent *Interval* paintings. Riley also chose to include the first public showing of her 2012 painting *Joy of Living: Homage to Matisse* feeling that its joyous message was very timely in these difficult times.

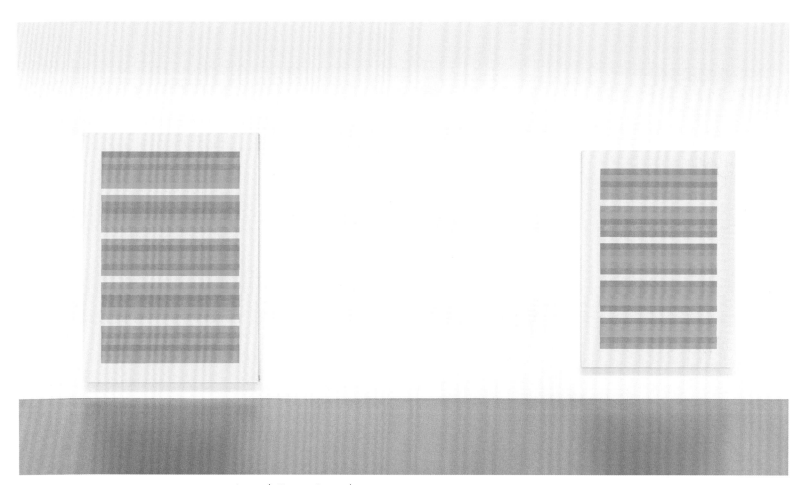

Installation view, Goethestraße 2/3, Berlin 2020: *Intervals 8*, 2020; *Intervals 9*, 2019

LIST OF EXHIBITED WORKS

BLEIBTREUSTRASSE 45

Blue Return, 1984
Oil on linen
177 x 153 cm (69 ³/₄ x 60 ¹/₄ inches)
The Lambrecht-Schadeberg Collection,
Museum für Gegenwartskunst Siegen
pages **13**, 20, 21

Arcadia 1 (Wall Painting 1), 2007
Graphite and acrylic on wall
239 x 441 cm (94 ¹/₈ x 173 ⁵/₈ inches)
Private Collection, Derbyshire
pages **14/15**, 21, 22/23

Red Overture, 2012
Oil on linen
186 x 353 cm (73 ¹/₄ x 139 inches)
Private Collection, Derbyshire
pages **18/19**, 20

Blue Counterpoint, 2014
Oil on linen
160 x 305 cm (63 x 120 ¹/₈ inches)
The Lambrecht-Schadeberg Collection,
Museum für Gegenwartskunst Siegen
pages **16/17**

BLEIBTREUSTRASSE 15/16

Rêve, 1999
Oil on linen
228 x 238 cm (89 ³/₄ x 93 ³/₄ inches)
Private Collection
pages **6/7**, 9

Joy of Living: Homage to Matisse, 2012
Acrylic on linen
158 x 421.5 cm (62 ¹/₄ x 166 inches)
Private Collection
pages 4, 8, **10/11**

GOETHESTRASSE 2/3

Vapour 2, 2009
Acrylic on linen
152.2 x 130 cm (59 ⁷/₈ x 51 ¹/₈ inches)
Private Collection
pages 34, **39**

Quiver 3, 2014
Graphite and acrylic paint on wall
241 x 744 cm (94 ⁷/₈ x 292 ⁷/₈ inches)
Private Collection
pages 32/33, **35–37**

Cascando, 2015
Acrylic on APF polyester support
140.6 x 458.6 cm (55 ³/₈ x 180 ¹/₂ inches)
Private Collection
pages 33, **42/43**, 45, 55

Rustle 2, 2015
Acrylic on APF polyester support
196.5 x 196.5 cm (77 ³/₈ x 77 ³/₈ inches)
Private Collection
pages **41**, 44

Measure for Measure 13, 2017
Acrylic on canvas
156.8 x 156 cm (61 ³/₄ x 61 ³/₈ inches)
Private Collection
pages 44, **49**, 54

Study for Measure for Measure 13, 2017
Acrylic on polyester
64 x 63.5 cm (25 ¹/₄ x 25 inches)
Private Collection
pages 44, **47**

Intervals 1, 2019
Oil on linen
198.5 x 145.5 cm (78 ¹/₈ x 57 ¹/₄ inches)
Private Collection
pages 32, **57**

Intervals 7, 2020
Oil on linen
265 x 189 cm (104 $^3/_8$ x 74 $^5/_8$ inches)
pages 55, **59**

Intervals 8, 2020
Oil on linen
265 x 189 cm (104 $^3/_8$ x 74 $^3/_8$ inches)
pages 45, 55, **61**, 75

Intervals 9, 2019
Oil on linen
231 x 167.3 cm (91 x 65 $^7/_8$ inches)
pages 55, **63**, 75

Measure for Measure 42, 2020
Acrylic on linen
120.7 x 229.8 cm (47 $^1/_2$ x 90 $^1/_2$ inches)
pages **50/51**, 54

Measure for Measure 43, 2020
Acrylic on linen
102 x 304.5 cm (40 $^1/_8$ x 119 $^7/_8$ inches)
pages **52/53**

Bridget Riley: Paintings 1984 – 2020
Essay: Éric de Chassey. Biograhical notes: Robert Kudielka. Copy editing: Lutz Eitel. Design: Hans Werner Holzwarth
Photographs: def image, Berlin, except: Courtesy Bridget Riley Archive (24, 27); Courtesy The Dallas Museum of Art (29);
Anna Arca (31); Jörg von Bruchhausen (64); Florian von Kleinefenn (72 top); Charles Duprat (72 bottom)
Lithographs: Bildpunkt, Berlin. Production: Medialis Offsetdruck, Berlin
Cover: *Intervals 1*, 2019 (detail)
© Bridget Riley 2020, all rights reserved. Copyright for the text: the authors; for the photographs: the photographers. Copyright
for this edition: Galerie Max Hetzler Berlin | Paris | London, Bleibtreustraße 45, 10623 Berlin | 57, Rue du Temple, 75004 Paris |
41 Dover Street, London W1S 4NS, www.maxhetzler.com, and Holzwarth Publications, www.holzwarth-publications.de
All rights reserved. First edition 2020. ISBN 978-3-947127-25-2. Printed in Germany

Max Hetzler would like to extend his warmest thanks to Bridget Riley
for this landmark exhibition. Special thanks also go to Éric de Chassey for
his insightful catalogue essay and Robert Kudielka for the comprehensive
biographical notes.

A final thank you to The Lambrecht-Schadeberg Collection, Museum
für Gegenwartskunst Siegen, and all private lenders who wish to remain
anonymous. Without their loans and support the exhibition would not
have been possible.